AROUND THE WORLD
in 80 COLORS
~
Coloring Across the Continents

BOUTIQUE SHA EDITORIAL

The Drawings

Introduction

The 36 illustrations in this book celebrate famous locales and heritage sites, ready for you to color your way around the world with colored pencils and a little imagination. There are no rules. Use realistic hues or something more unusual. Color the sky blue ... or maybe lime green? Whichever colors you choose, they will be your own unique expression of these intriguing places.

We recommend using colored pencils or fine-pointed crayons for coloring the illustrations in this book. Watercolors or markers can bleed through the paper, so please photocopy the illustration onto a suitable paper first if you prefer to use these materials.

Tools and Tips for Coloring

For coloring large open areas of the page like a sky or a field, try shading or cross-hatching. Different coloring techniques will add texture and subtlety to your drawing.

Ready to get more adventurous? Add a 3-D effect to round objects such as pillars or tree trunks by layering a lighter or darker color on top of the object's main color. This enables you to create highlights or shadows that add depth.

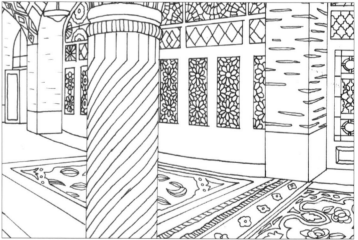
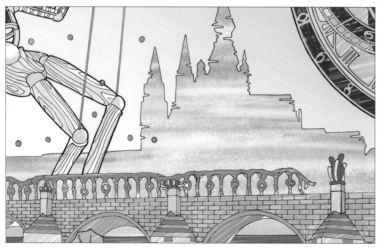
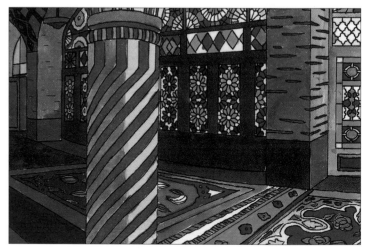

Be careful of the order in which you use your selected colors, as this will affect the final result. You may find it helpful to plan your coloring to start with lighter colors, and then switch to progressively darker shades.

Inspiration for Coloring

Here are colored examples of each of the illustrations in this book. You can refer to these when looking for inspiration for your own coloring.

1. The Amalfi Coast (Italy)

The Amalfi Coast in Southern Italy offers some of the most scenic vistas in Europe. Colorful buildings decorate the steep cliffs along the Sorrento Peninsula as the Tyrrhenian Sea glimmers in the background. Enjoy the scenery and dreamy local treats like Italian tomatoes, sun-ripened lemons, and fresh pasta.

Composition & drawing/Okachimachi Arashiyama

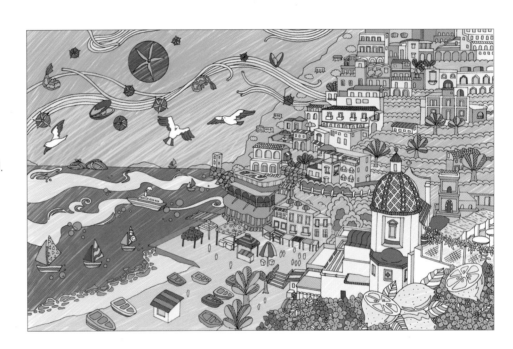

2. The Carnival of Venice (Italy)

Comprised of more than 100 small islands, Venice has been nicknamed the City of Water and Queen of the Adriatic Sea. Waterbuses, water taxis, and boats carry passengers across the many canals that weave through the islands. The Carnival of Venice, an annual festival in the city, is world-renowned for the elaborate masks worn by attendees.

Composition & drawing/Okachimachi Arashiyama

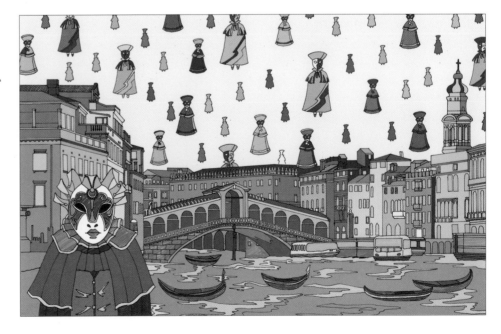

3. Saint Basil's Cathedral in Moscow (Russia)

In the 16th century, Ivan the Terrible built this world-famous cathedral. It is located just outside the walls of the Kremlin in Moscow. A set of intricate matryoshka nesting dolls stand guard in the foreground, while pink salmon, a local specialty in eastern Russia, frolic in the background.

Composition & drawing/XIAN OZN

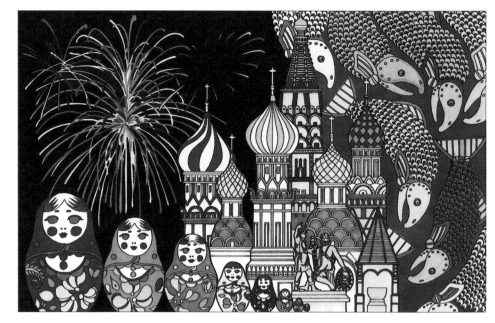

4. Prague Castle & Charles Bridge (Czech Republic)

Prague looks like a storybook city. The city boasts stunning views from famous landmarks such as the Charles Bridge and Prague Castle, especially at sunset. The city is also famous for handcrafted marionettes, and for being the home of the world's third-oldest astronomical clock.

Composition & drawing/XIAN OZN

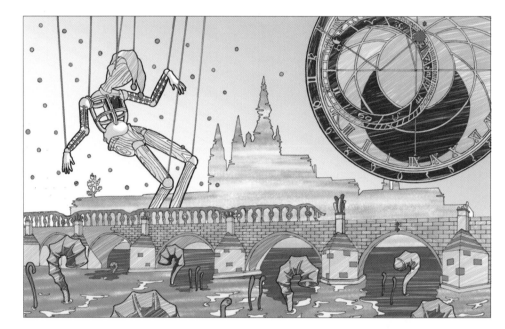

5. Neuschwanstein Castle (Germany)

Germany is the land of fairy tales and home to one of the most magical castles in the world—Neuschwanstein Castle. It was built in the second half of the nineteenth century by Ludwig II of Bavaria and is also known as the Castle of the Fairy-Tale King.

Composition & drawing/Okachimachi Arashiyama

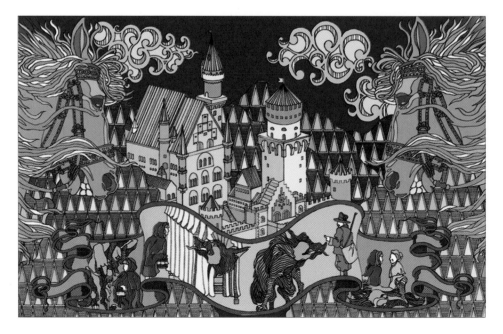

6. Tulips and Windmills (Holland)

Holland, or as it is officially named, The Netherlands, is known for picturesque, historic towns and a stunning countryside dotted with iconic windmills and colorful tulip fields. The Dutch are fond of riding bicycles in the countryside and cities alike. This illustration invites you to be bold and bright in your coloring!

Composition & drawing/Okachimachi Arashiyama

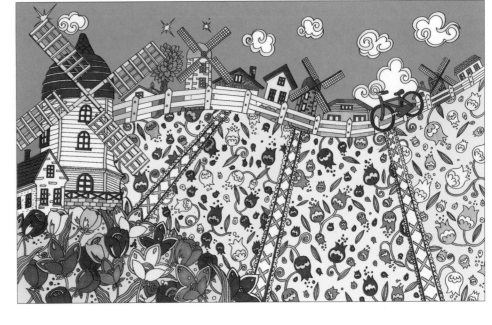

7. London: Past and Present (England)

London is a contemporary city full of sites both historic and new. This illustration celebrates a few of the city's many landmarks, including the Tower Bridge, Big Ben, and the London Eye. England's most famous fictional little girl, Alice from *Alice in Wonderland* by Lewis Carroll, is also featured in this picture.

Composition & drawing/Okachimachi Arashiyama

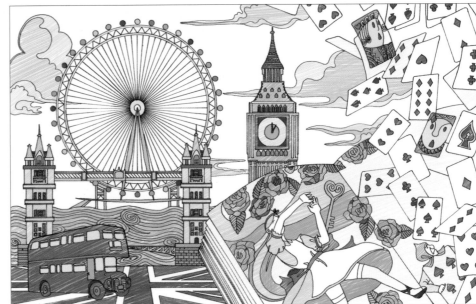

8. Paris, The City of Light (France)

Paris is called the City of Light because of its vibrant art, culture, and evening vistas. The artist Henri de Toulouse-Lautrec painted many scenes at the colorful Moulin Rouge cabaret. The famed Arc de Triumph sits at the meeting point of 12 straight avenues, historically known as the Place de l'Étoile, and now known as the Place de Gaulle, in honor of the wartime general and postwar president Charles de Gaulle.

Composition & drawing/XIAN OZN

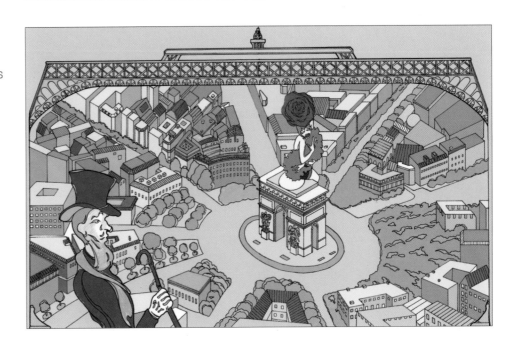

9. Notre Dame of Paris (France)
10. Canterbury Cathedral (England)
11. Chartres Cathedral (France)
12. Strasbourg Cathedral (France)

The art of stained glass dates back as far as the fifth century. Magnificent examples of stained glass can be found in some of Europe's most famous cathedrals. Enjoy coloring these amazing and detailed designs from Notre Dame of Paris, the Chartres Cathedral, the Strasbourg Cathedral, and the Canterbury Cathedral.

Composition & drawing/Okachimachi Arashiyama (9 & 12) XIAN OZN (10 & 11)

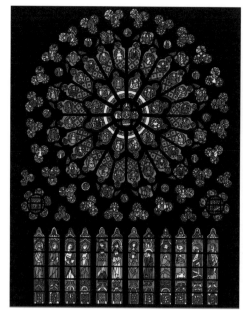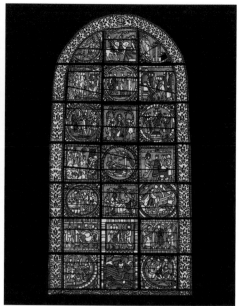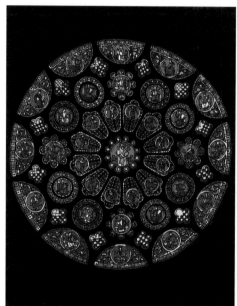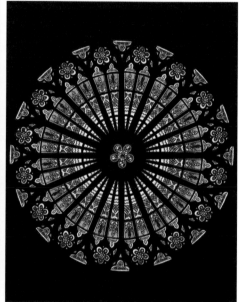

13. Barcelona's Sagrada Família (Spain)

The Sagrada Família (Basilica of the Holy Family), a UNESCO World Heritage Site, is located in Barcelona, the capital city of Spain's Catalonia region. This famous church designed by the Spanish architect Antoni Gaudi has been under construction for over 130 years! The drawing features a large Spanish flag fluttering in the background, and a matador and bull also make an appearance to round out a Spanish experience.

Composition & drawing/XIAN OZN

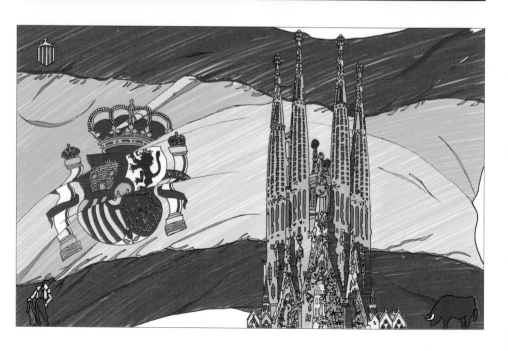

14. The Umbrella Canopy in Águeda (Portugal)

This "umbrella street" in Águeda, Portugal is on display every July. Red, blue, yellow, green, pink, and orange umbrellas decorate the sky and attract many tourists from around the world. Feel free to color the buildings, flowers, and walkways with bright hues too!

Composition/ XIAN OZN, drawing/Okachimachi Arashiyama

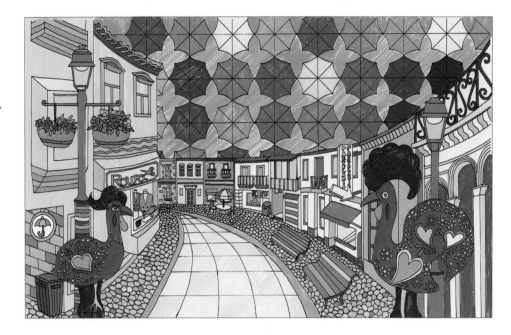

15. Splendid Stockholm (Sweden)

Stockholm is the capital of Sweden and is the most populated area of the Nordic region. Made up of 14 islands, Stockholm is surrounded by water. This design features a variety of popular Nordic symbols, including dala horses, elk, and owls, as well as a Viking ship.

Composition & drawing/Okachimachi Arashiyama

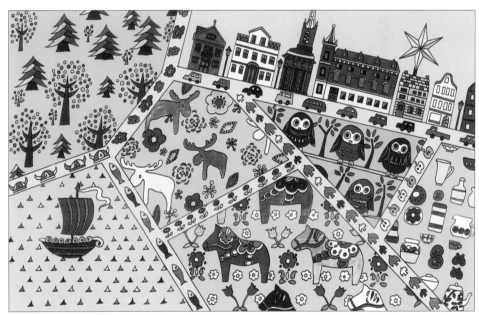

16. Santa Claus Village of Rovaniemi (Finland)

There really is a Santa Claus Village located in the Arctic Circle in Northern Finland. All mail sent from this post office is stamped with a special Santa Claus postmark. Enjoy coloring the decorative ornaments, glowing candles, and magical snow globe.

Composition & drawing/non.

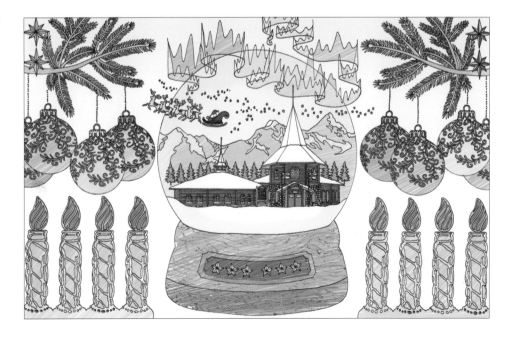

17. Cappadocia's Fairy Chimneys (Turkey)

Cappadocia is a historical region in Turkey famous for naturally occurring volcanic rocks known as "fairy chimneys." Tourists take hot air balloon rides to view the unique landscape of this UNESCO World Heritage site. The drawing includes a visiting horse from the ancient city of Troy.

Composition & drawing/Okachimachi Arashiyama

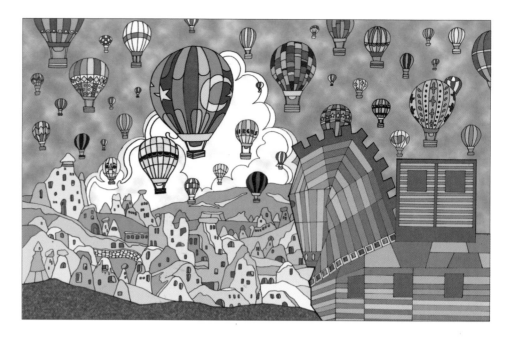

18. Istanbul's Blue Mosque (Turkey)

Istanbul's Blue Mosque was built in the 17th century and is considered a classic example of architecture from the Ottoman Empire. The interior of the mosque is lined with more than 20,000 handmade ceramic tiles—all in varying shades of blue. Color this picture in blues, or create your own colorful interpretation.

Composition & drawing/Okachimachi Arashiyama

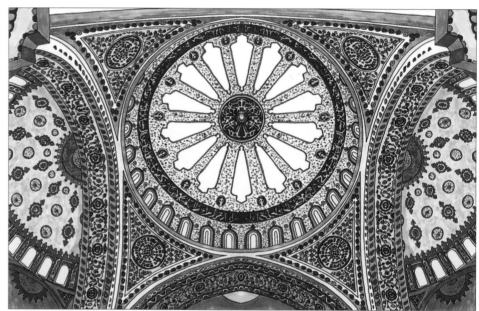

19. The Pink Mosque of Shiraz (Iran)

Astonishing colorful stained glass and Persian carpets adorn the insides of "Nasir ol Molk Mosque," also known as the Pink Mosque. When the sun shines through the colorful stained glass windows, an amazing kaleidoscope of colors dance and sparkle.

Composition & drawing/Okachimachi Arashiyama

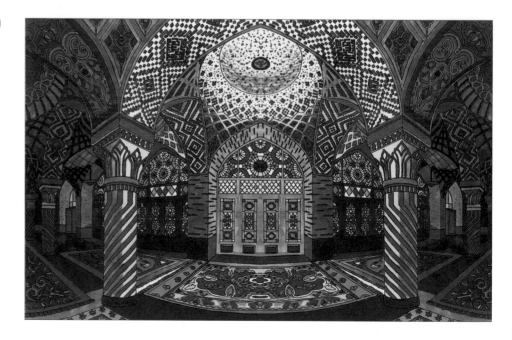

20. The Great Pyramids of Giza (Egypt)

The Great Pyramids of Giza were built over 4,500 years ago as tombs for Pharaohs of ancient Egypt. The ancient Egyptians are also famous for hieroglyphics, a pictorial form of writing. In this unique picture, hieroglyphics and other ancient Egyptian symbols float above the pyramids, waiting to be colored...

Composition & drawing/Okachimachi Arashiyama

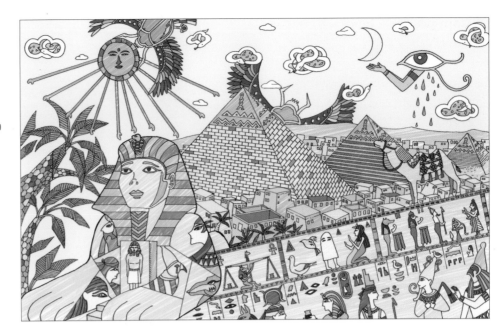

21. The African Savanna

A stunning variety of wildlife populates the African Savanna, which spreads across parts of more than 25 different nations. Animals native to the African savanna include elephants, zebras, horses, and giraffes. In this picture, a rainbow sun shines on all the plants and animals of the Savanna.

Composition & drawing/Okachimachi Arashiyama

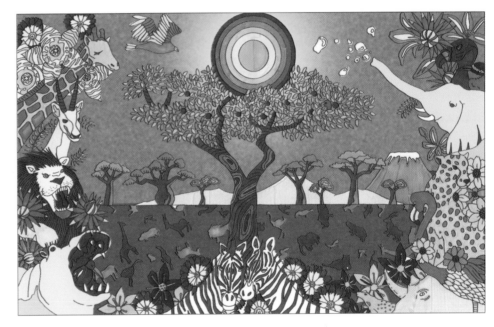

22. Mount Fuji's Cherry Blossoms (Japan)

Mt. Fuji is a sacred mountain in Japan that has been worshiped throughout the ages. The views of Mt. Fuji are especially magnificent during the cherry blossom season when the trees are covered with beautiful flowers. Elegant Japanese figures of the past also decorate this picture. Use any color you would like for the sky as a background!

Composition & drawing/Okachimachi Arashiyama

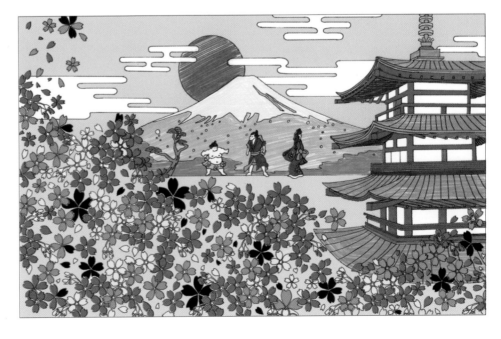

23. Kinkaku-ji Temple (Japan)

Kyoto is the ancient capital of Japan, known for historic temples and shrines. One of the most exquisite temples in Kyoko is Kinkaku-ji. Visitors from all over the world come to this temple, especially in the fall when its amazing gardens burst with vivid autumn hues.

Composition/non., drawing/Ishidayuu

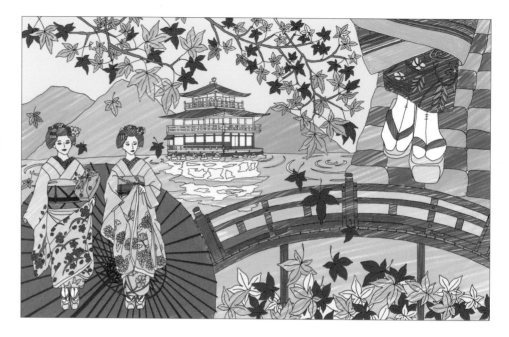

24. The Taj Mahal (India)

The Taj Mahal was built by the Emperor of the Mughal Empire for his beloved queen. The building and its gardens are perfectly symmetrical and took over 22 years to complete. While the real Taj Mahal is made of white marble, the drawing looks lovely with a variety of colors.

Composition & drawing/non.

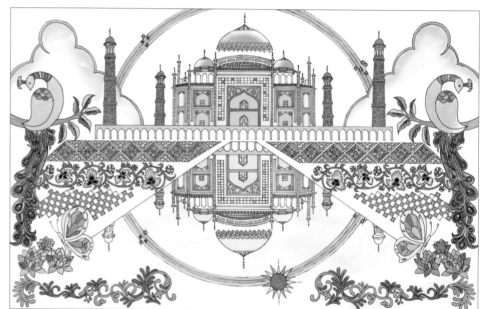

25. The Reclining Buddha at Wat Pho (Thailand)

The Wat Pho temple complex in Bangkok holds the largest collection of Buddha images and sculptures in all of Thailand. The highlight of this collection is the 150 foot-long gold Reclining Buddha. The soles of the Reclining Buddha's feet are inlaid with mother-of-pearl and intricate designs. There is a lot to color in this picture—including elegant elephants and tuk-tuk taxis!

Composition & drawing/XIAN OZN

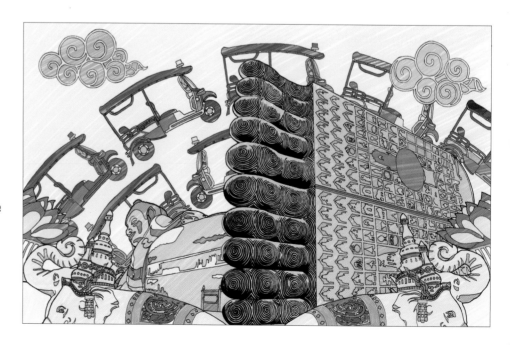

26. The Great Wall (China)

China's Great Wall dates back to the Qin Dynasty over 2,000 years ago, but the most famous parts of the wall were built in the 17th century during the Ming dynasty. It spans more than 12,400 miles (20,000 kilometers). The tigers, dragons, flowers, and pagodas are all famous icons of China.

Composition & drawing/Okachimachi Arashiyama

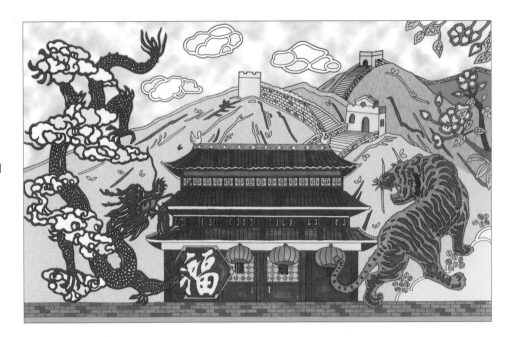

27. The Enchanting Village of Jiufen (Taiwan)

Jiufen is an exquisite and charming village on the northeast coast of Taiwan. It has breathtaking views of the Pacific Ocean and surrounding mountains. Jiufen's enchanting architecture draws tourists from all around the world and has provided inspiration for filmmakers and artists alike.

Composition & drawing/Okachimachi Arashiyama

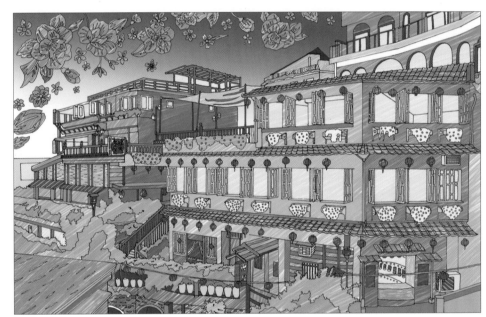

28. Hong Kong Harbor (China)

Hong Kong is a harbor city known for its "million dollar views." The city's sleek and modern skyscrapers look especially beautiful at night lit up with neon colors. In this picture, majestic evening fireworks burst over the harbor. Do you see the double decker bus? It's a reminder that Hong Kong was formerly a British colony.

Composition & drawing/hirocomoq

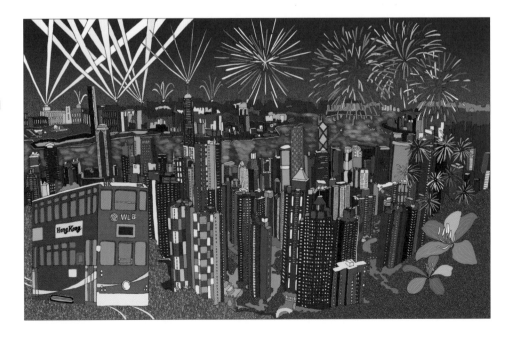

29. Aloha: Welcome to Hawaii's Waikiki Beach (USA)

Waikiki, on the island of Oahu, is the most popular beach in Hawaii. In this dreamy beach scene, sea turtles ride waves while colorful pineapples float in the water. On the shore, hula dancers perform around giant tropical flowers. From rainbows to surfboards, there is a lot to color in this picture.

Composition & drawing/Okachimachi Arashiyama

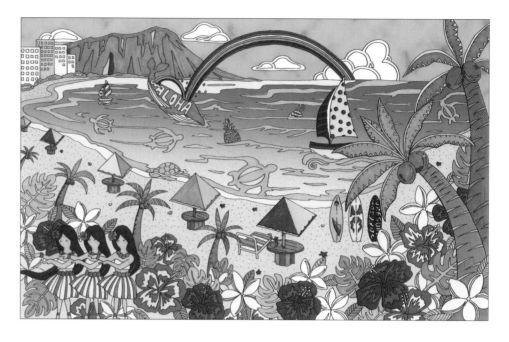

30. Route 66 (USA)

Route 66 was one of the first highways built in America. It ran for more than 2,300 miles (3,700 kilometers) from the Great Lakes, across the Midwest, through the Southwest, and on to California. While it is no longer marked on road maps, large parts of this iconic road still exist, and it is the inspiration for countless movies, songs, and novels.

Composition & drawing/non.

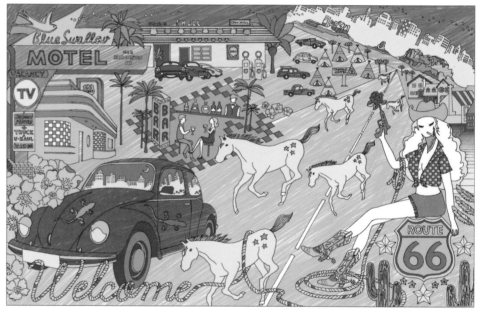

31. The Day of the Dead Festival (Mexico)

The Day of the Dead is a holiday celebrated in Mexico on the last day of October and the first two days of November. Families gather to honor their loved ones who have passed away. The celebration is a lively festival with colorful flowers and skull-shaped objects everywhere. This picture also pays respect to the ancient Mayan ruins of Chichen Itza found on Mexico's Yucatán Peninsula.

Composition & drawing/non.

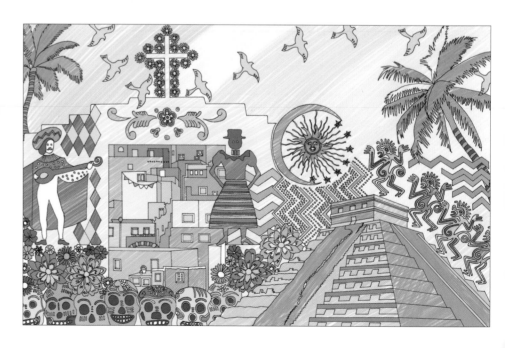

32. Machu Picchu (Peru)

Machu Picchu is a 15th century Incan site nearly 8,000 feet above sea level in the Andes Mountains of Peru. Machu Picchu is thought to have been a sacred place for the Incas. This postcard-like picture is framed with unique images of Incan gods. Llamas were first domesticated by the Incan people and can still be seen wandering around Machu Picchu today.

Composition & drawing/Okachimachi Arashiyama

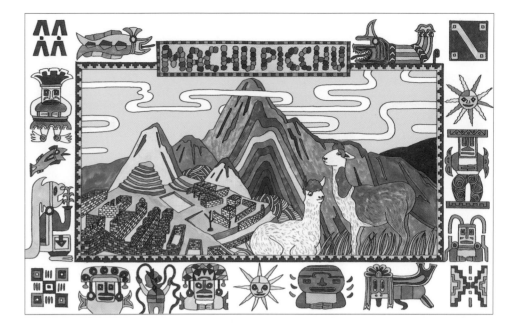

33. The Amazon Rainforest (Brazil)

The Amazon is the largest tropical forest in the world. It spans seven countries, but sixty percent of it sits within the borders of Brazil. Rare plants and animals live within this vibrant ecosystem. The sky's the limit when choosing colors for the flowers, creatures, and plants in this pictorial rainforest!

Composition & drawing/Okachimachi Arashiyama

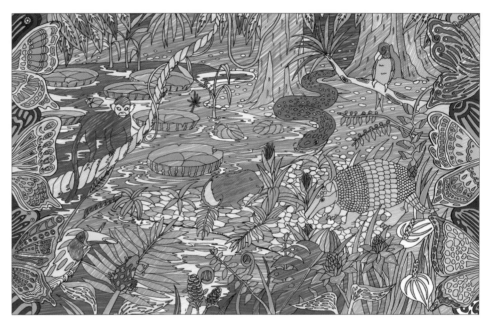

34. Rio de Janeiro (Brazil)

Rio de Janeiro is the second largest city in Brazil and is known for its beautiful beaches and annual Carnival. The Carnival of Brazil is a festival with colorful and fantastical costumes and parades. Corcovado Mountain rises over the city and provides stunning views for hikers. The gigantic statue Christ the Redeemer stands atop one of Corcovado's peaks and is a world-famous symbol of Rio. There is a lot to color in this picture, including soccer balls that represent Brazil's favorite sport!

Composition & drawing/Okachimachi Arashiyama

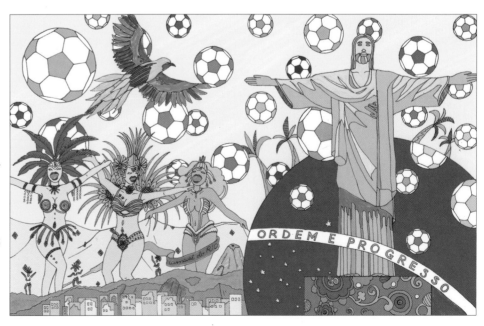

35. Great Barrier Reef (Australia)

The Great Barrier Reef is the most expansive coral reef ecosystem in the world and home to countless species of fish and other sea creatures. It is an environmentally protected area that stretches for 1,400 miles (2,200 kilometers) along the northeastern coast of Australia. It is a breathtaking place teeming with life. Use as many colors as you like for this vibrant picture.

Composition & drawing/Okachimachi Arashiyama

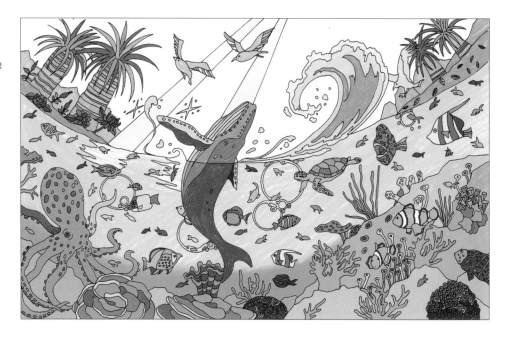

36. My Colorful World

Now's the time to color dreamlike floating dolls that represent regions from all around the globe. The last doll has been left blank so you can add your own pattern. Grab some colored pencils or crayons and help make the world a brighter place!

Composition & drawing/Okachimachi Arashiyama

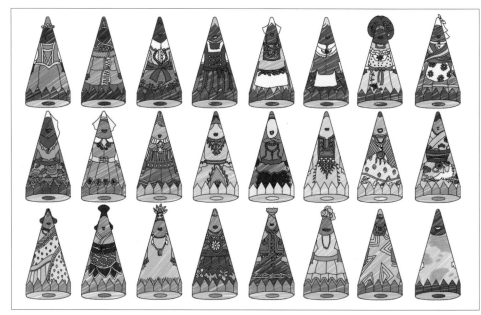

Begin Your Coloring Adventure Here

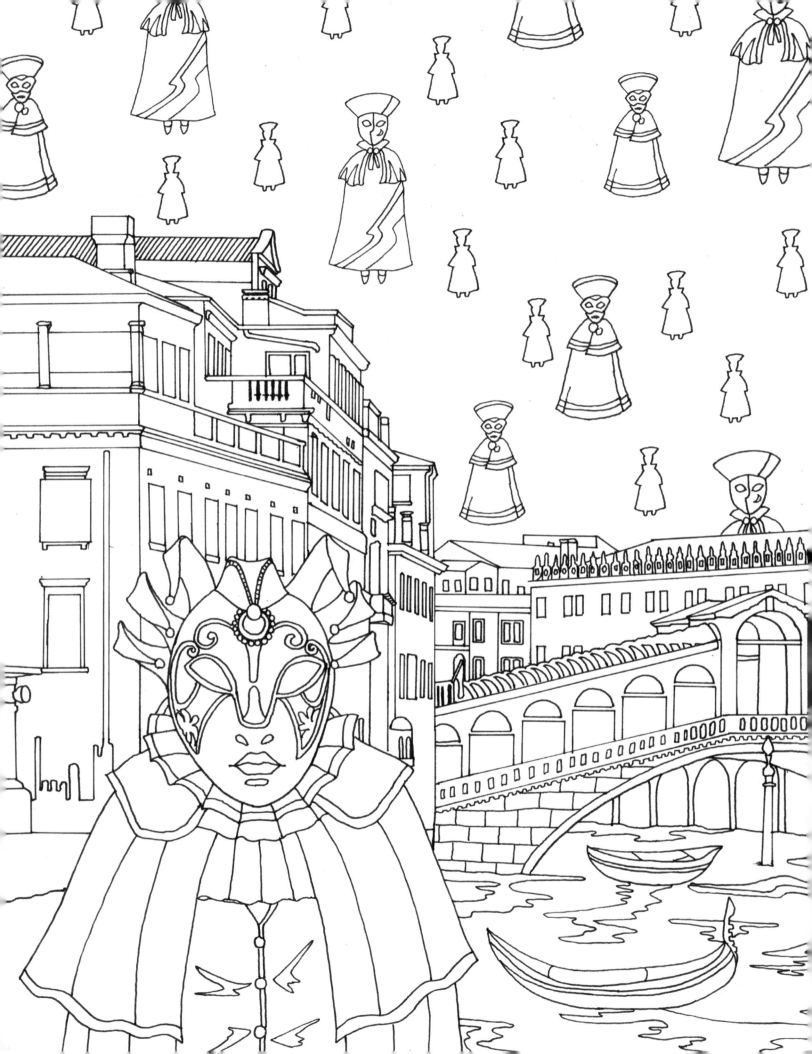

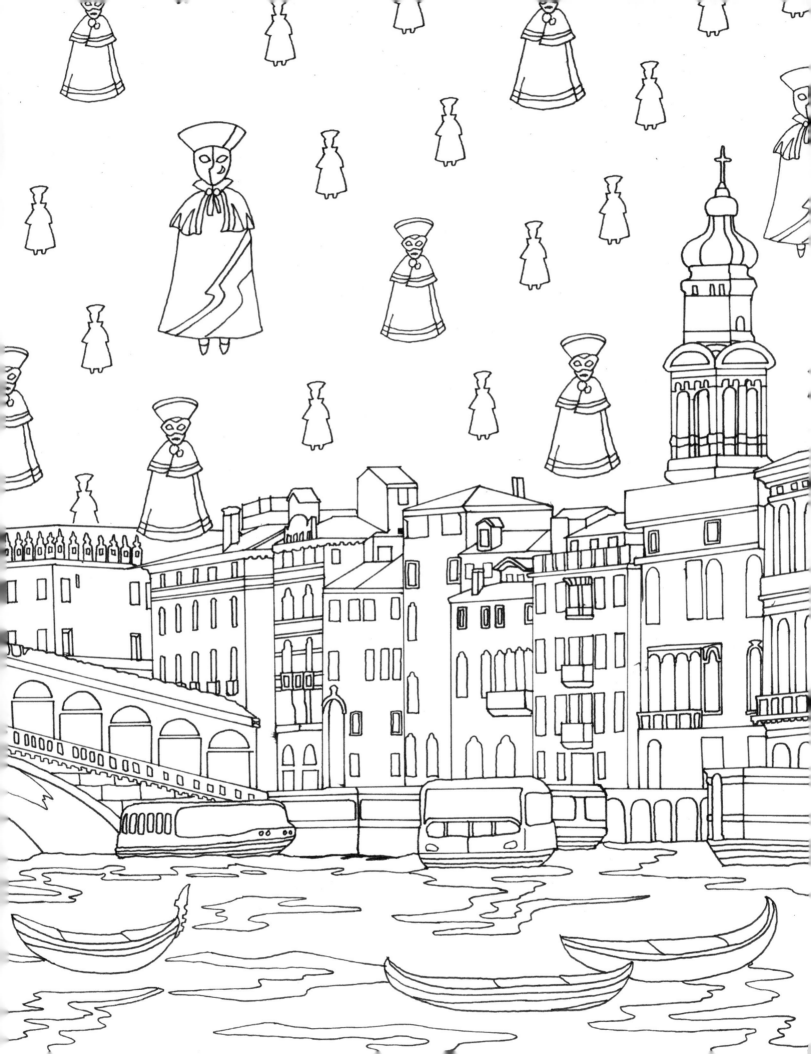

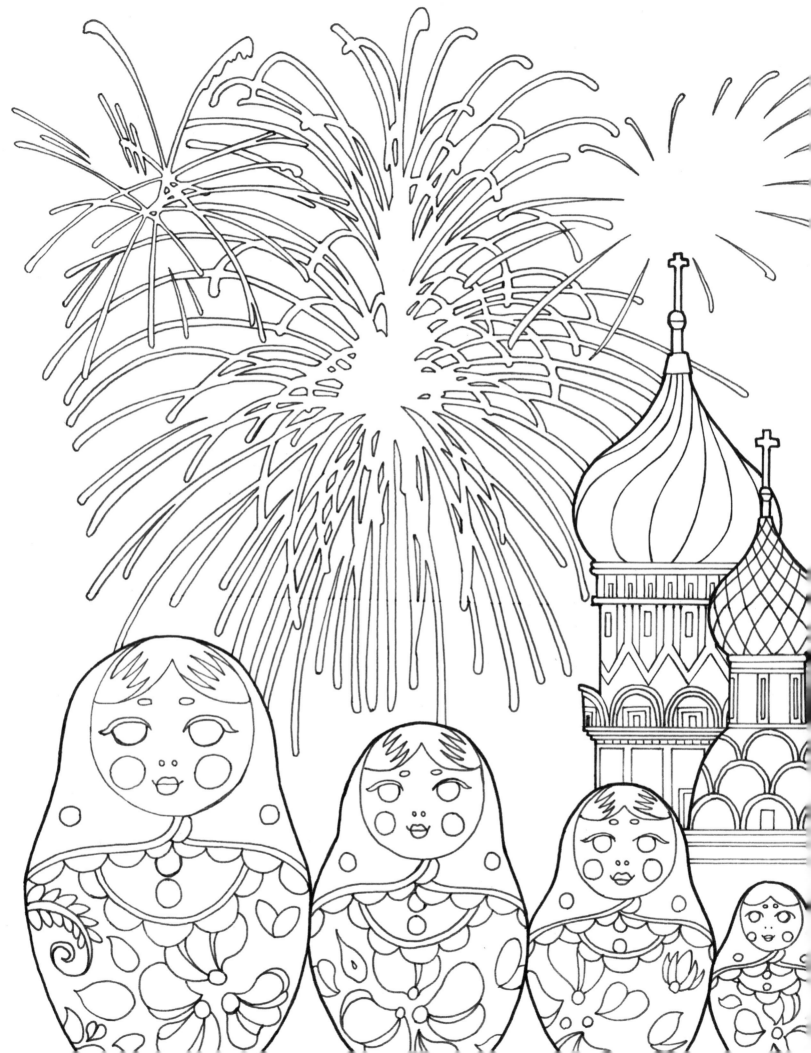

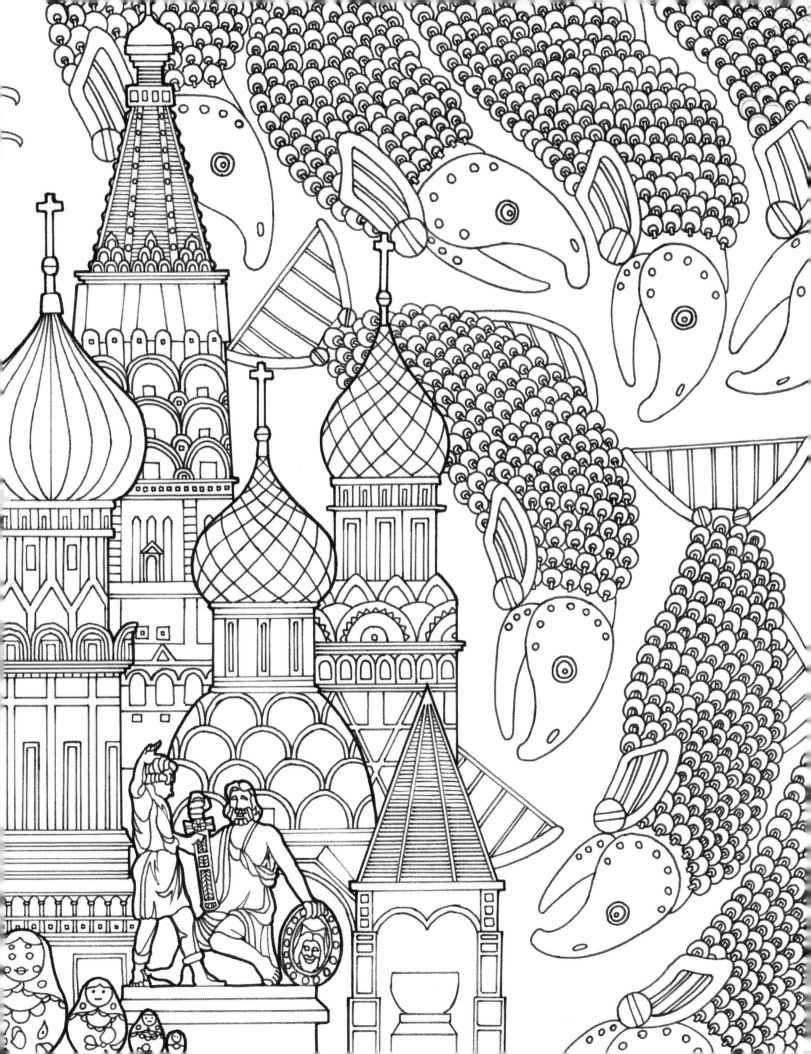

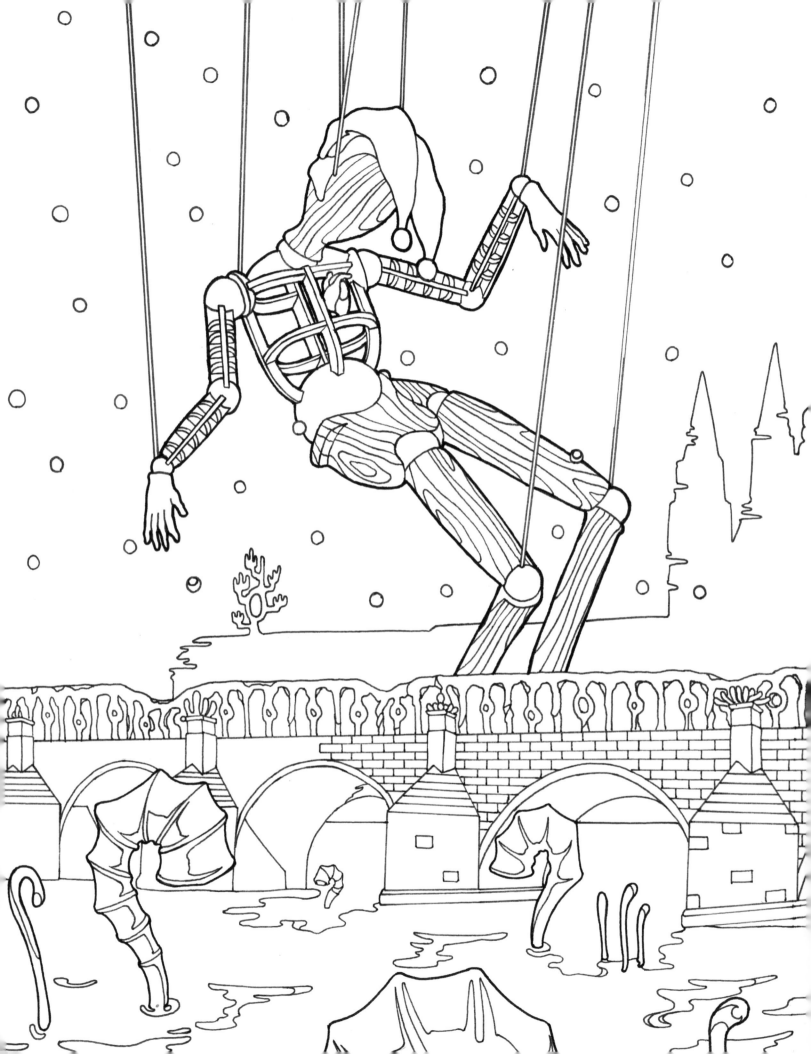

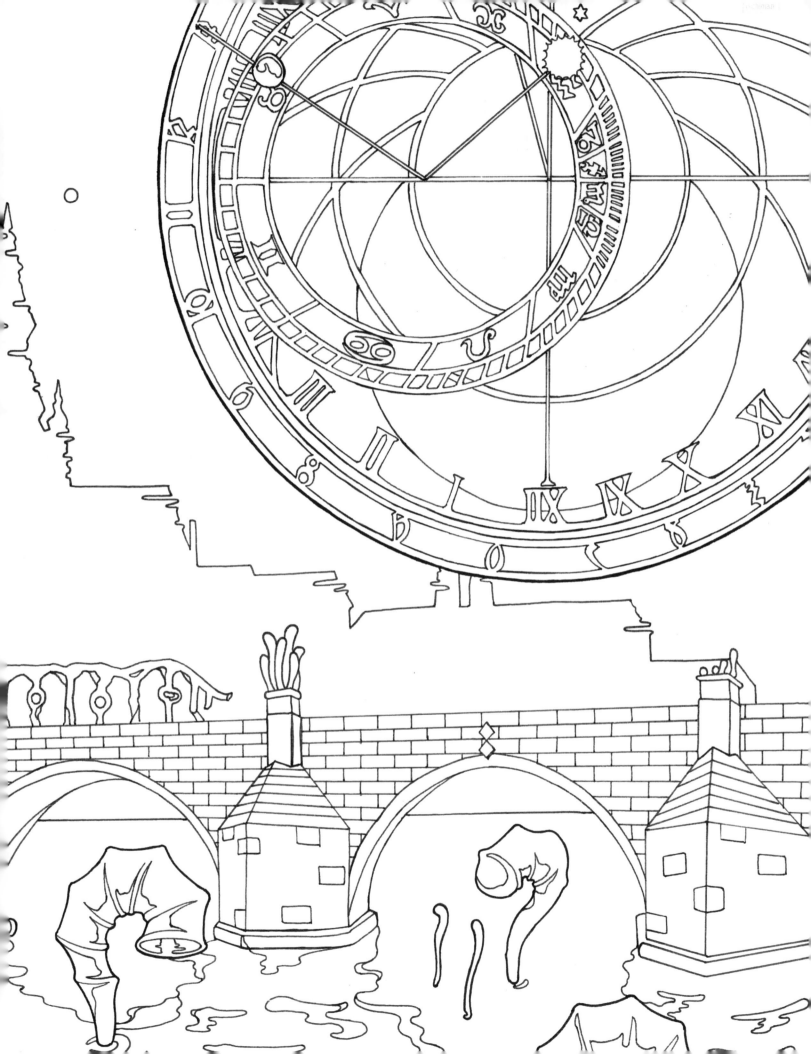

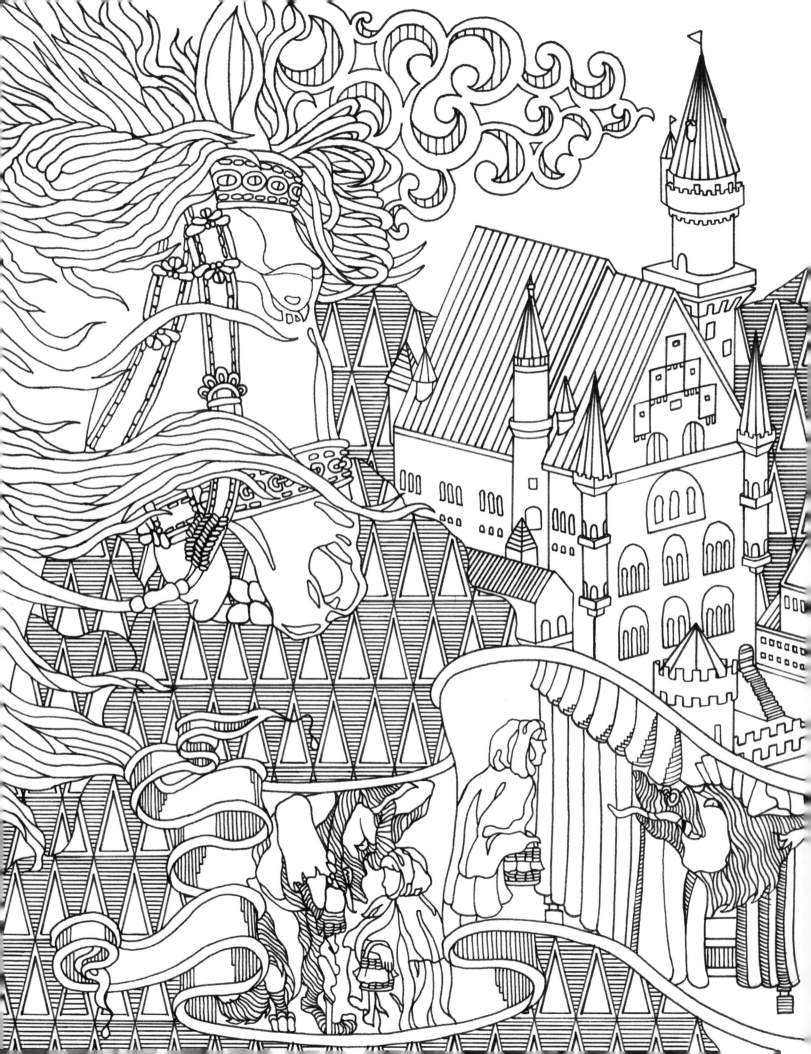

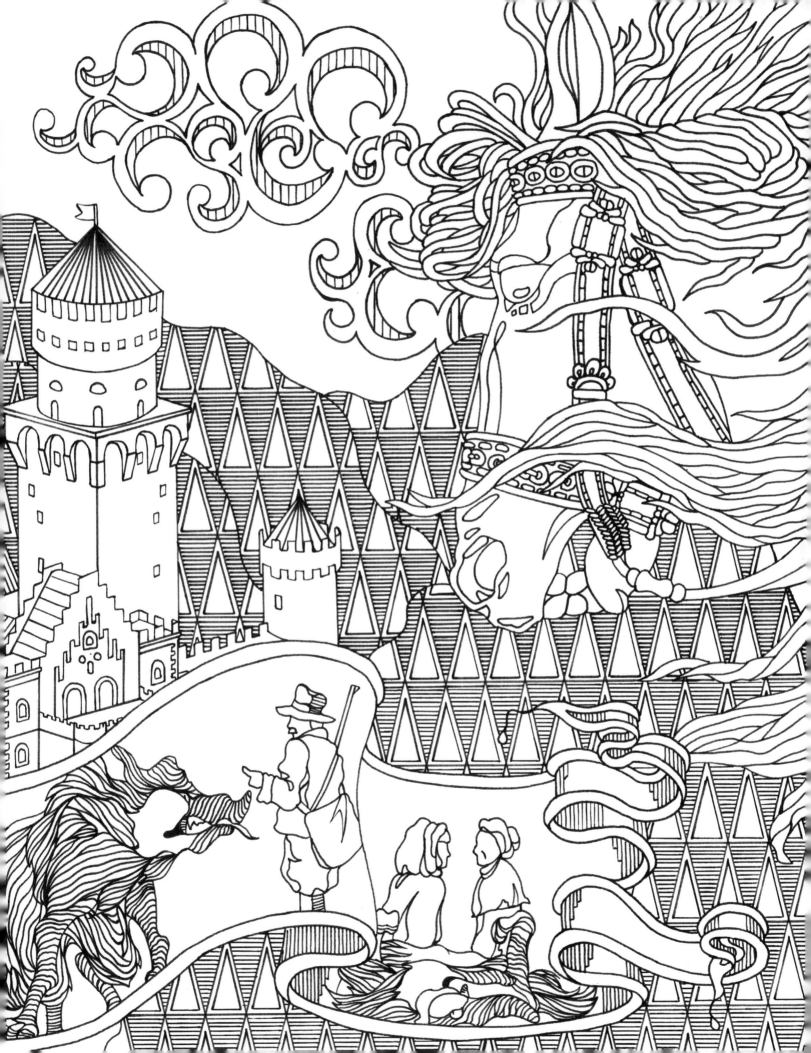

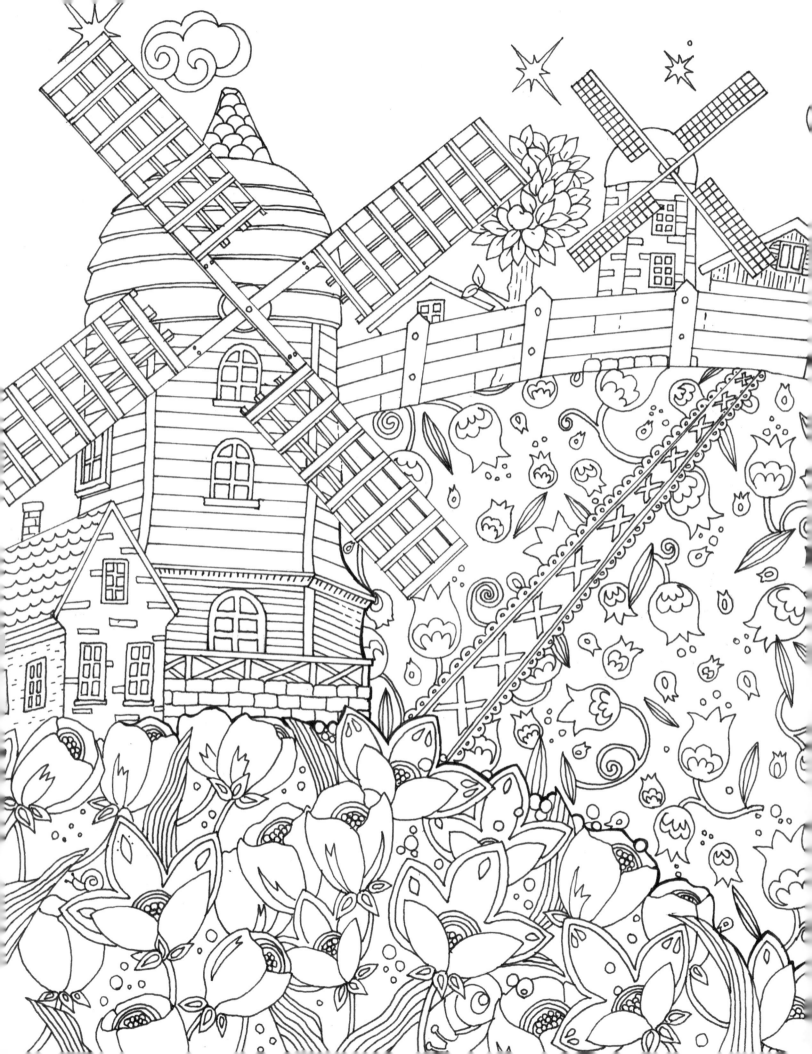

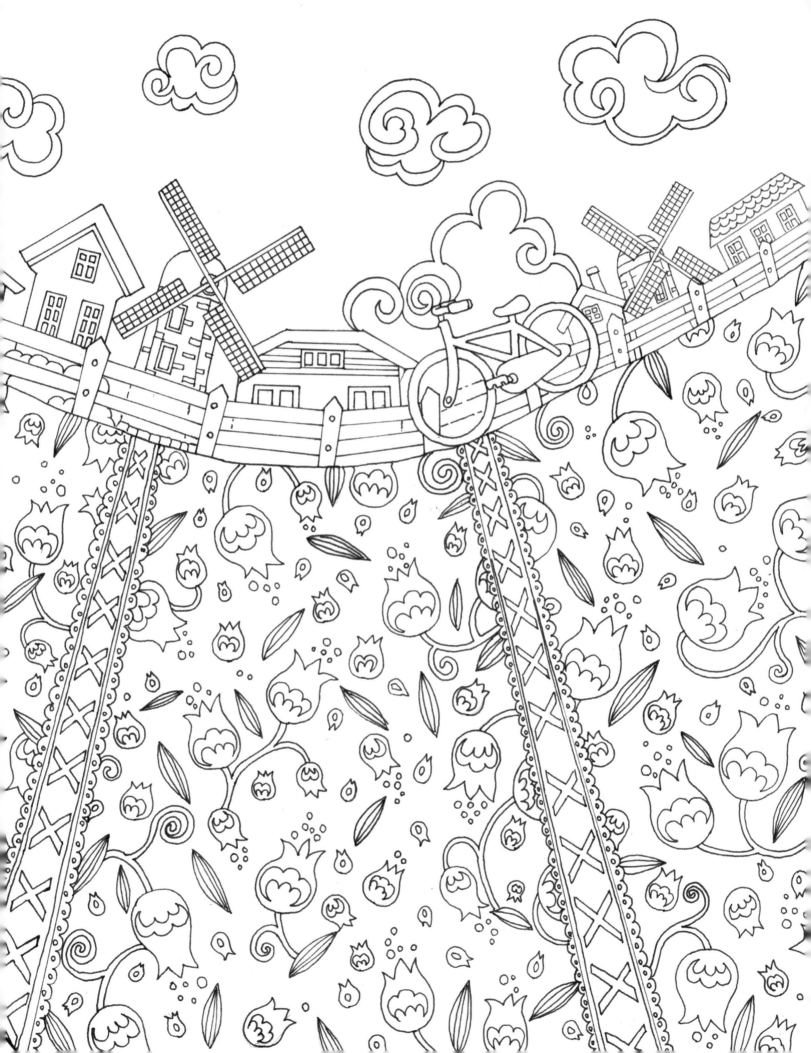

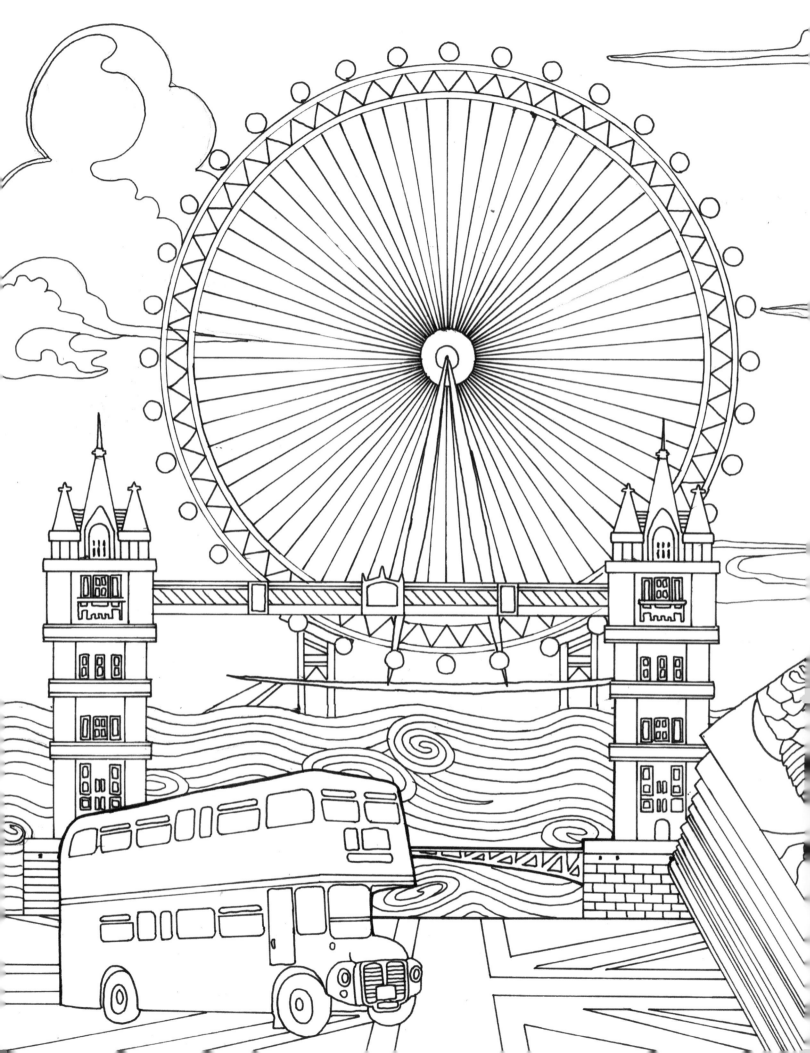

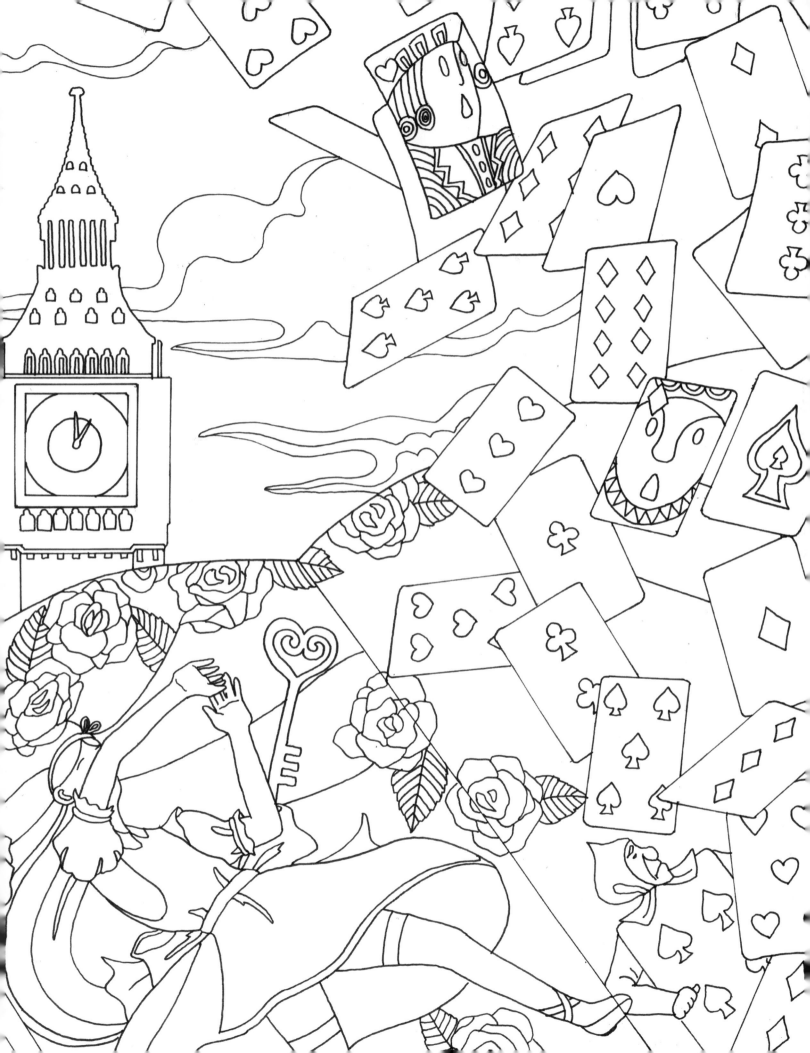

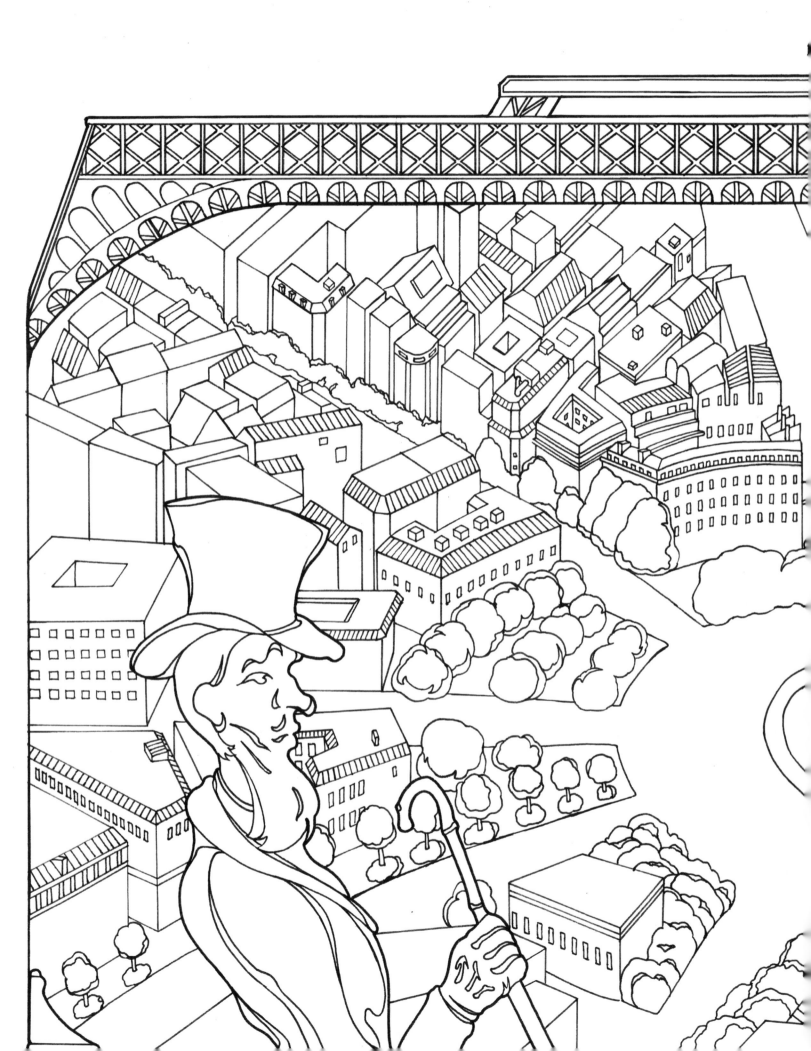

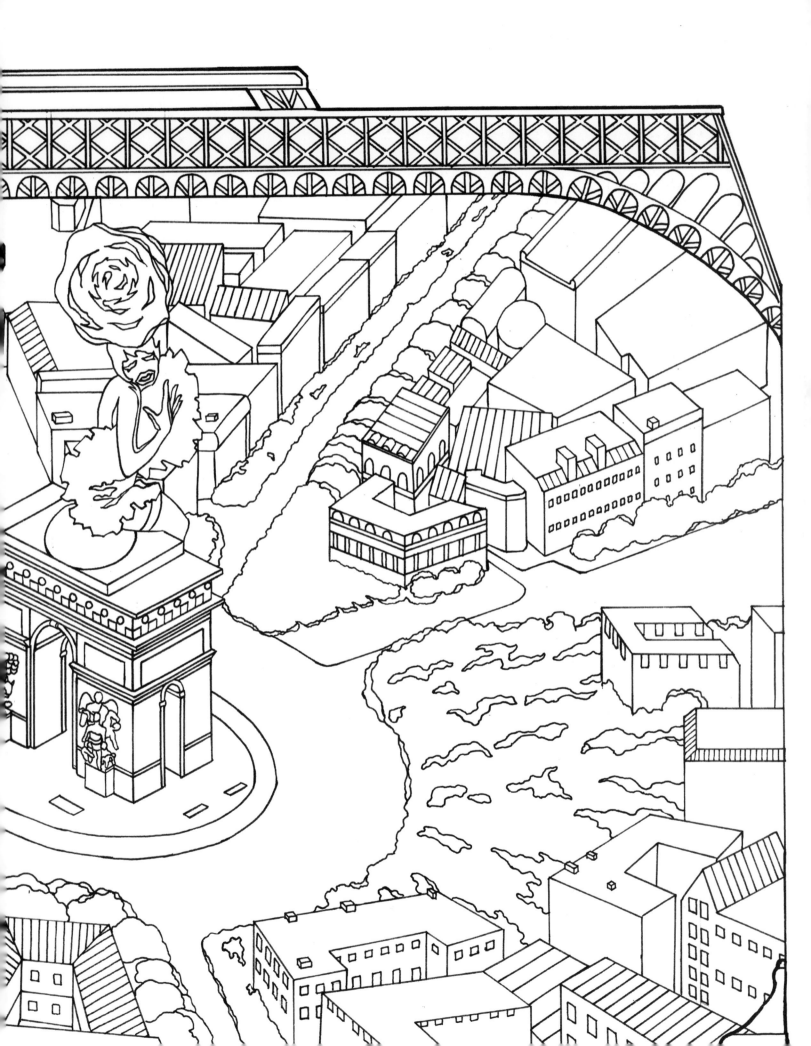

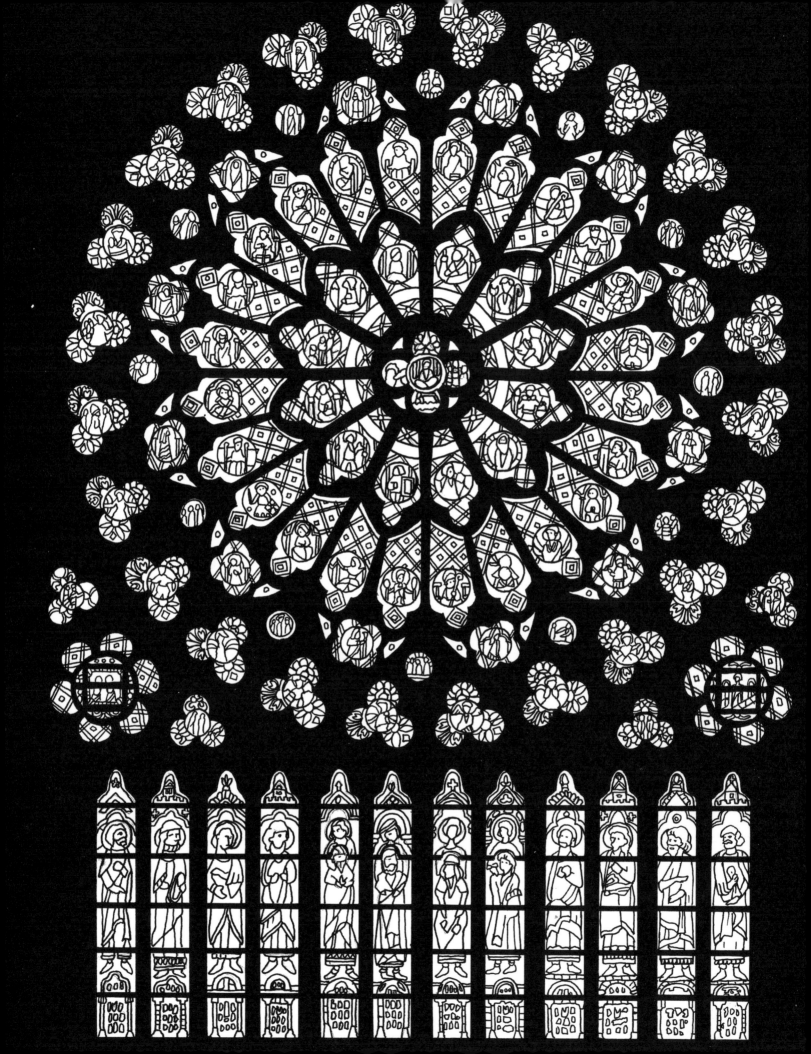

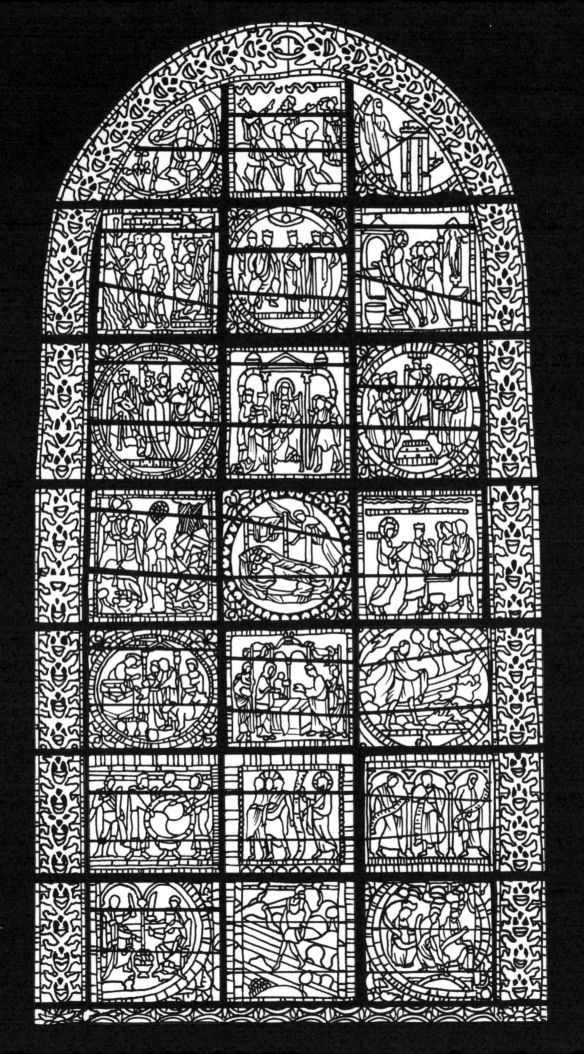

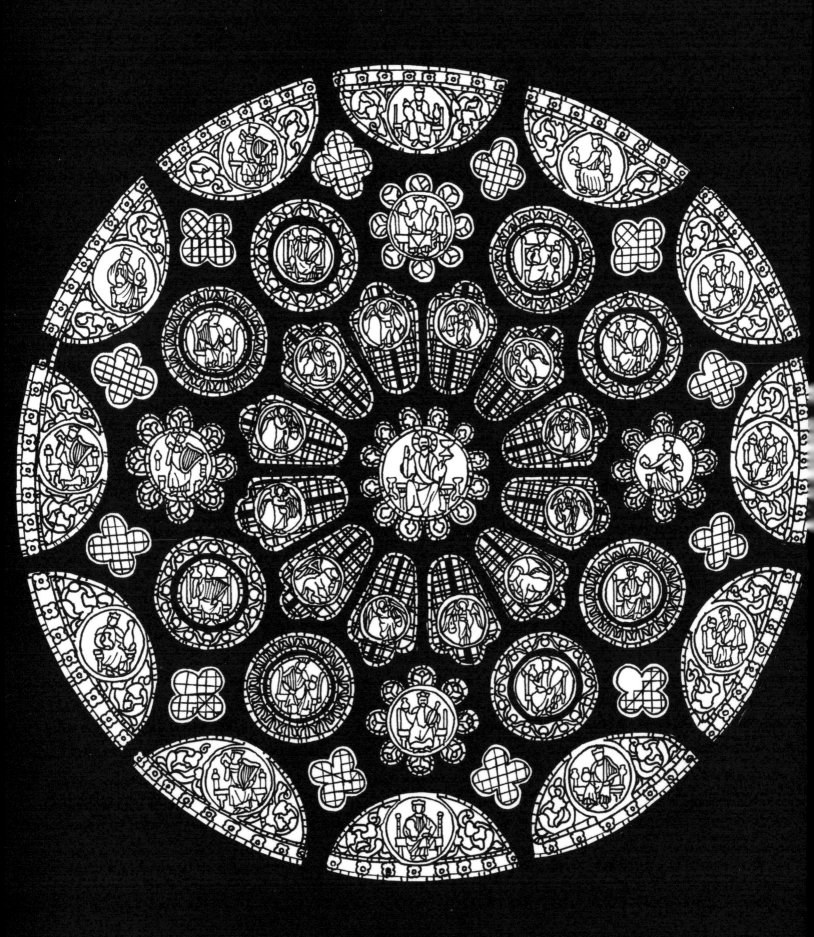

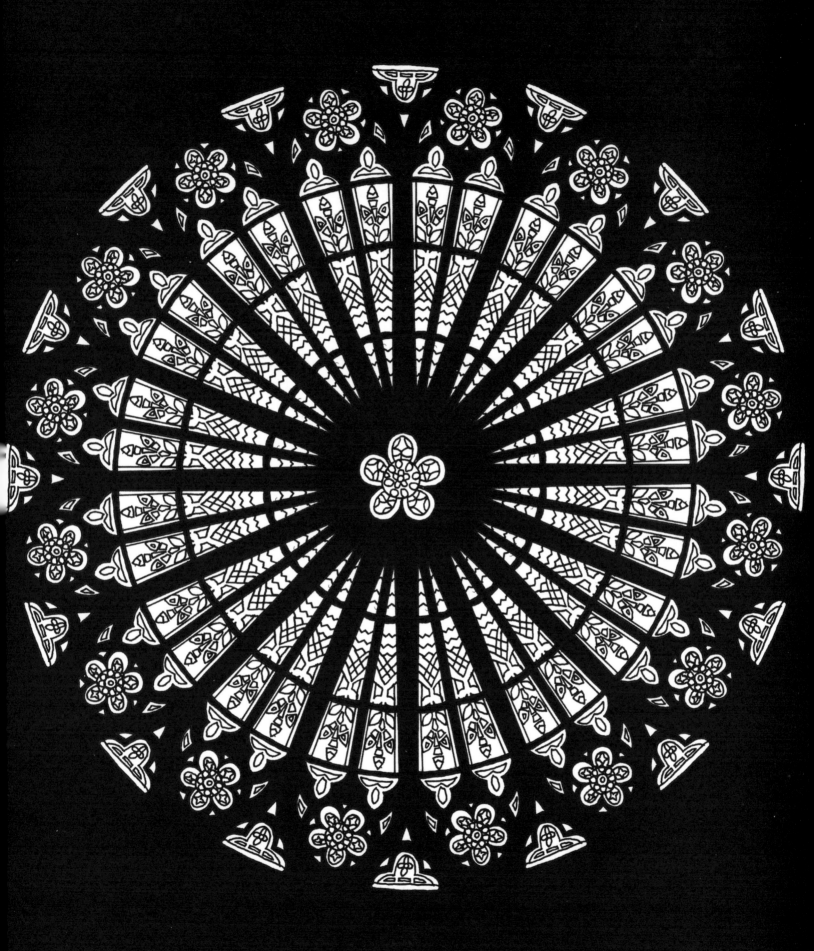

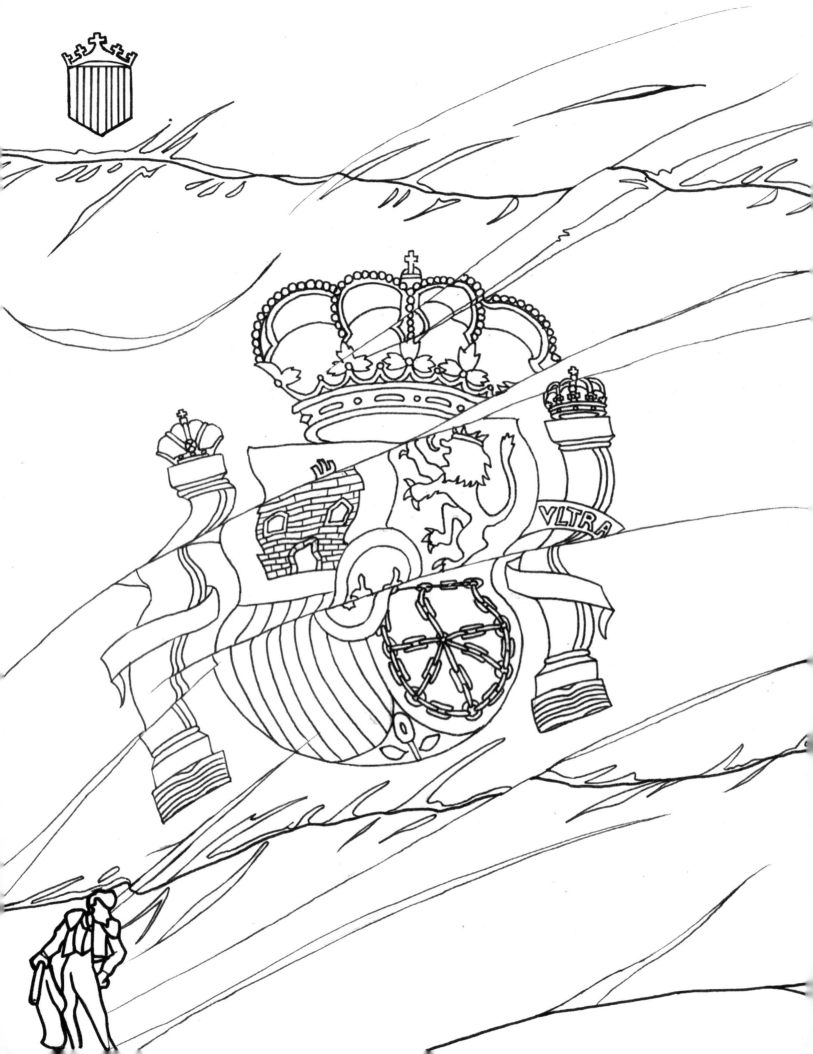

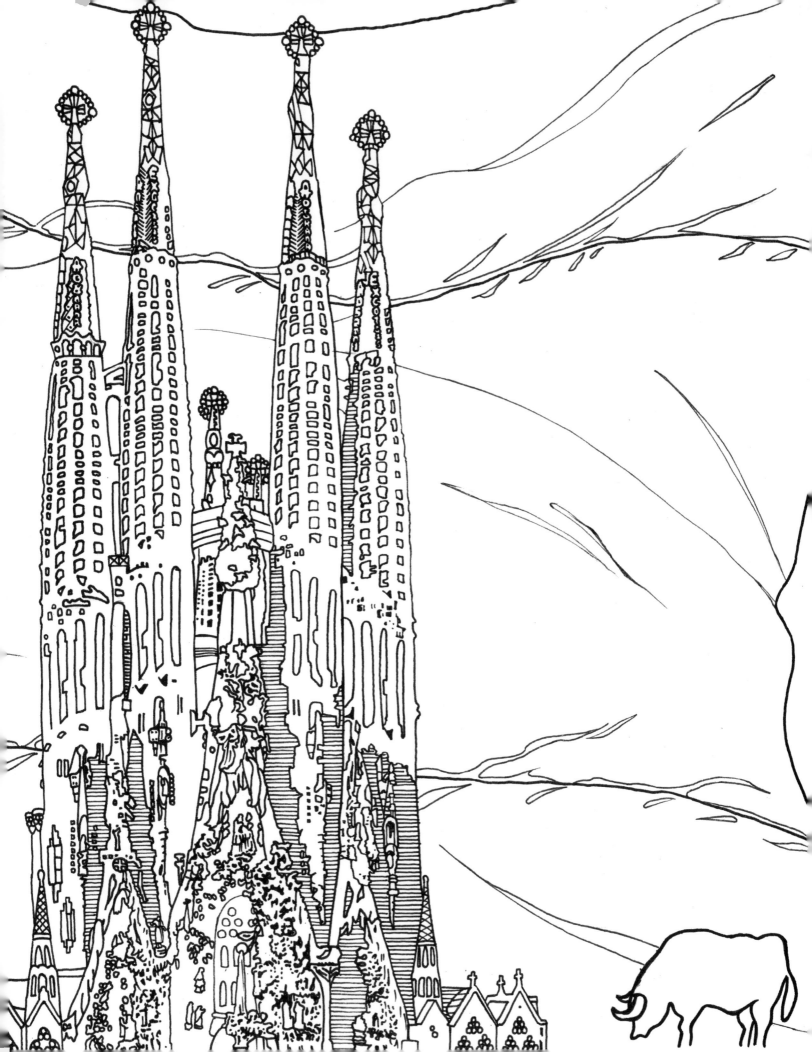

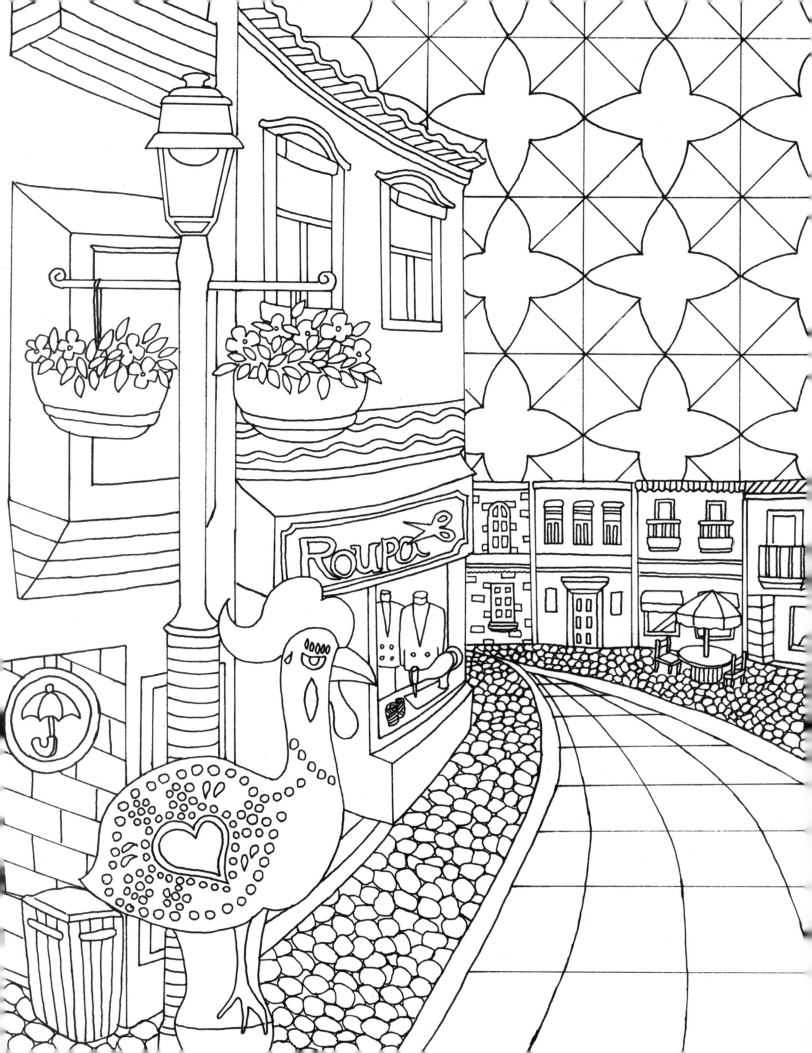

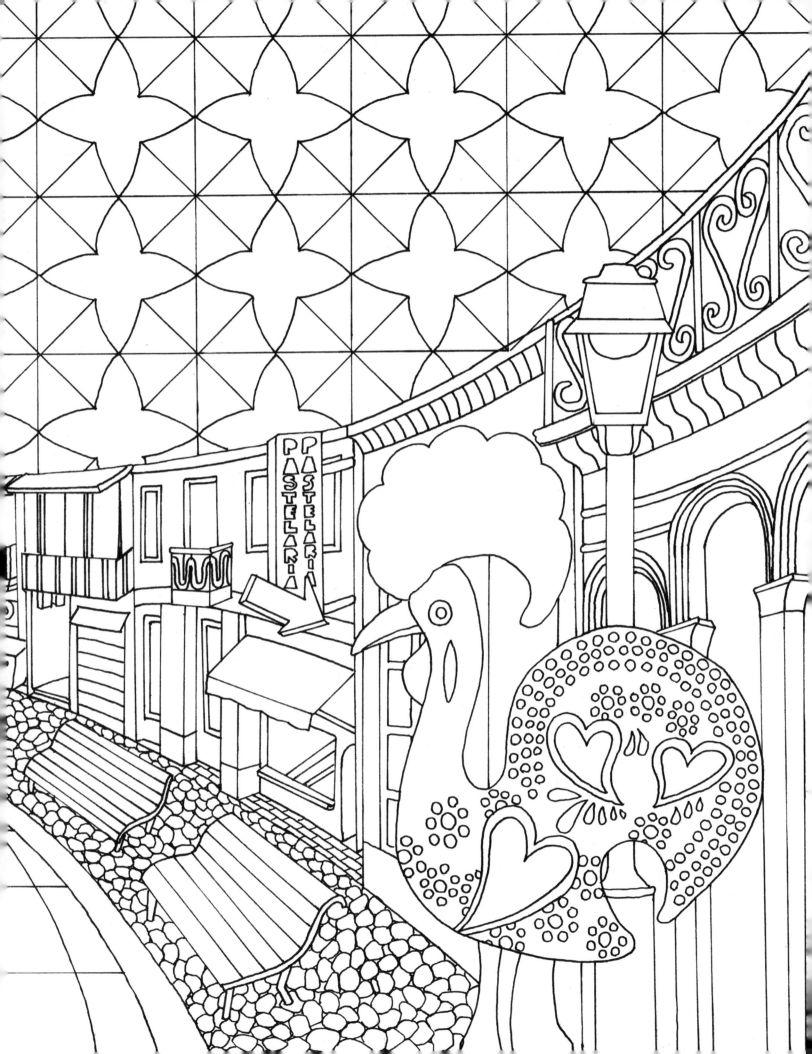

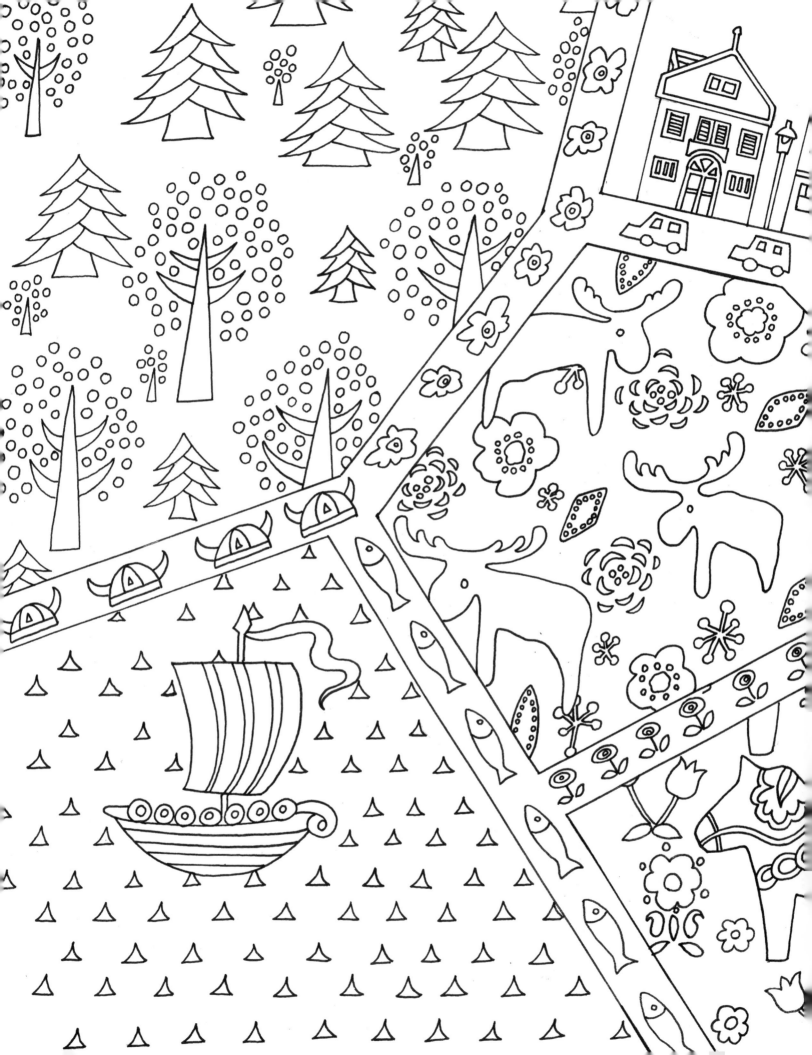

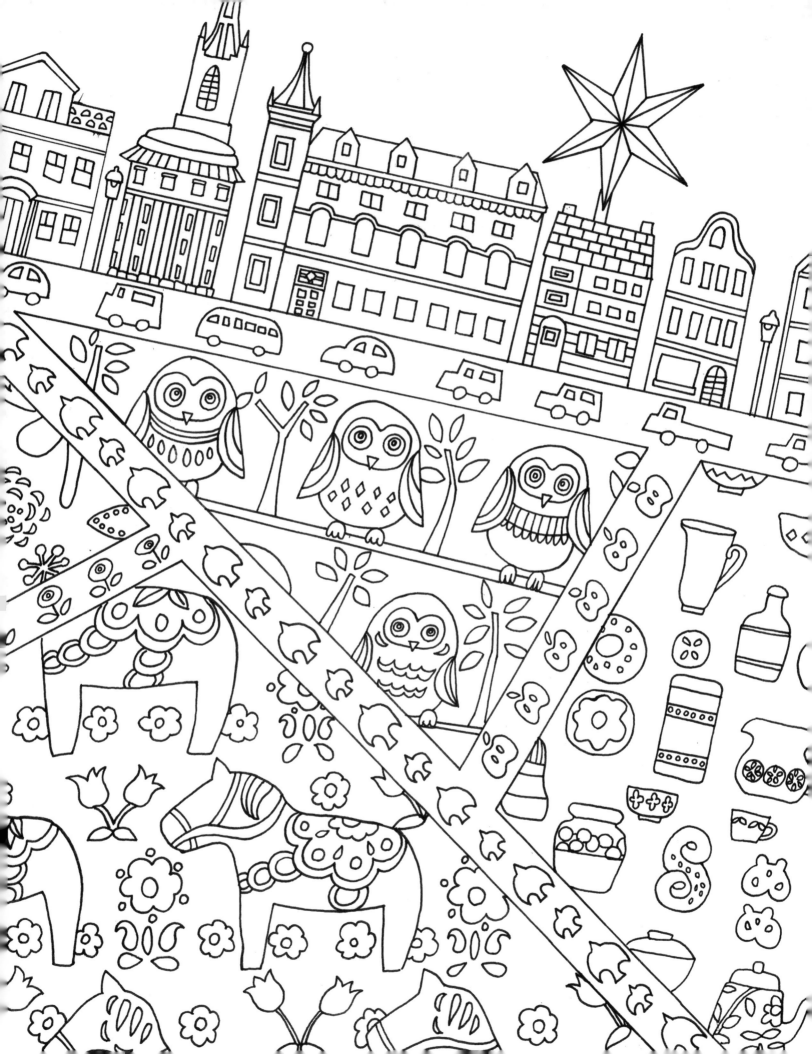

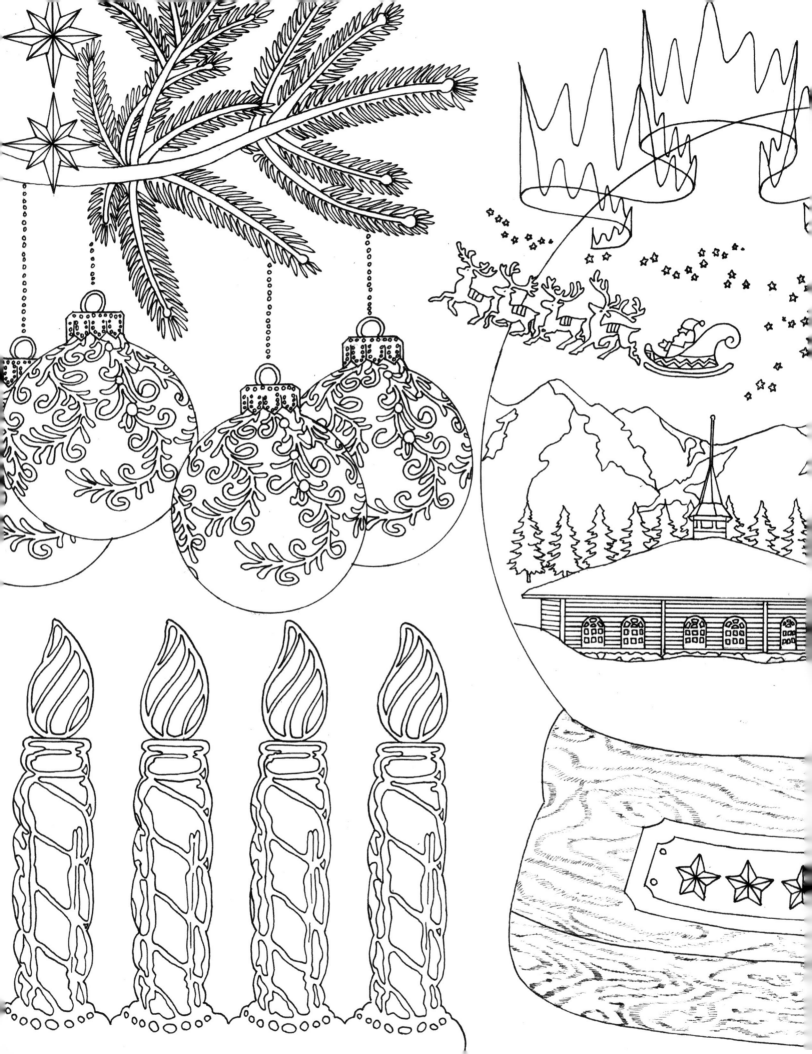

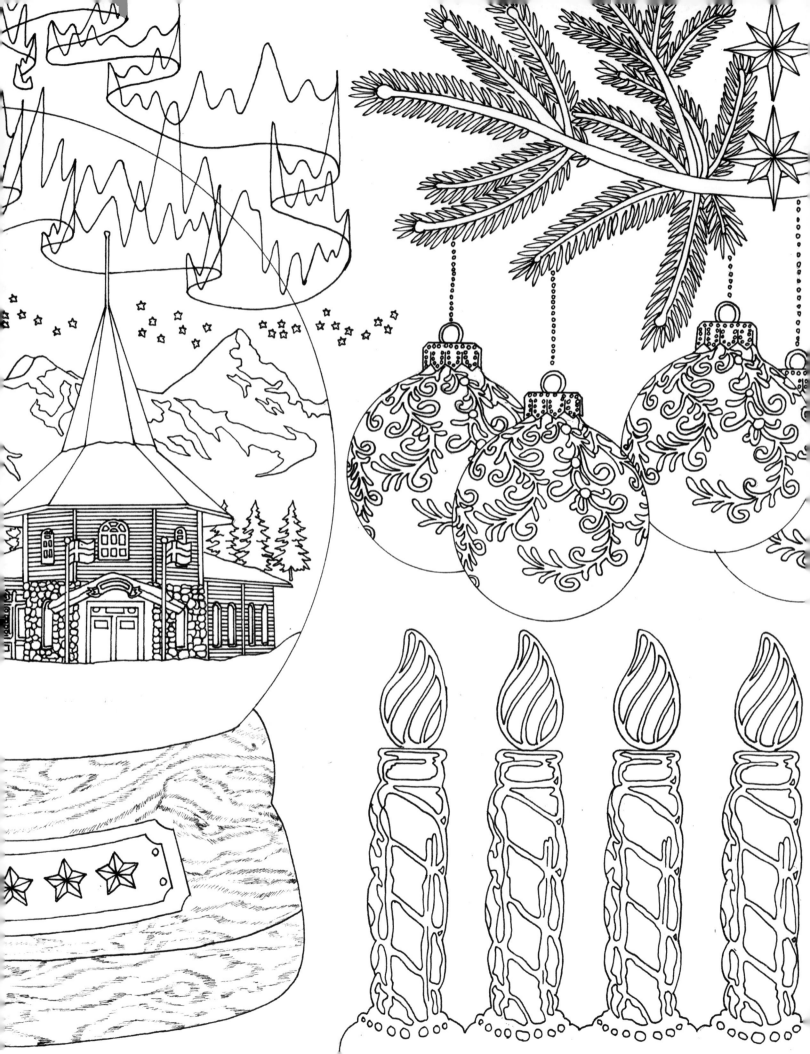

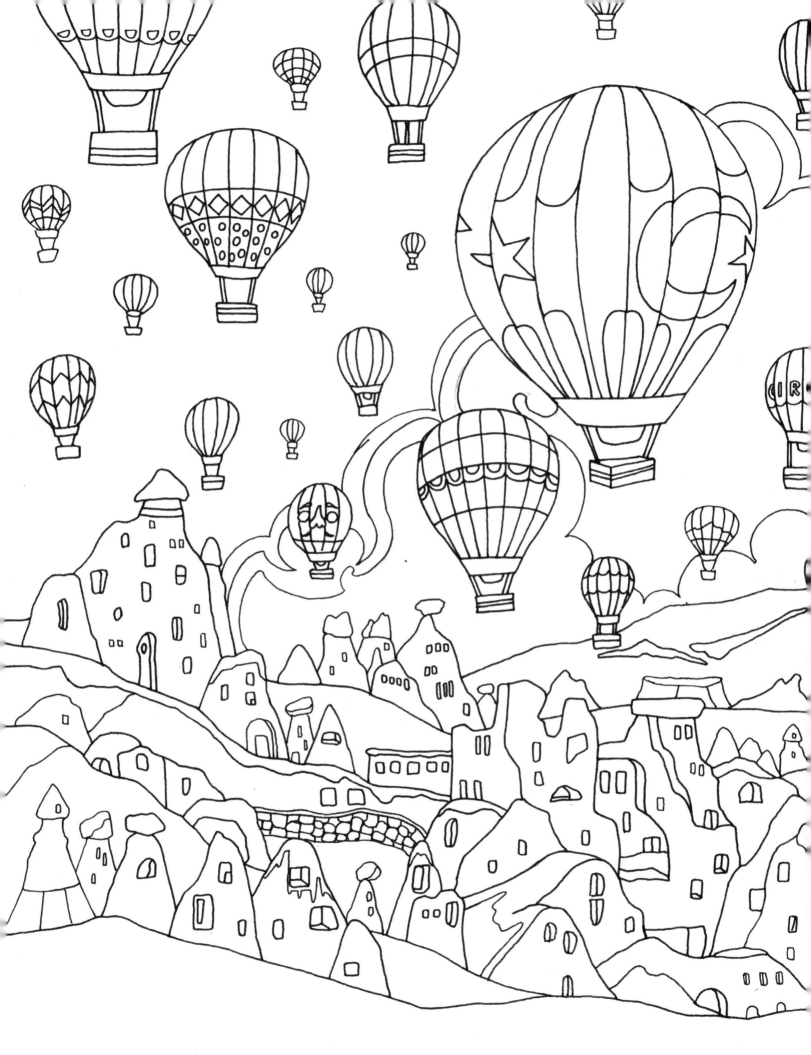

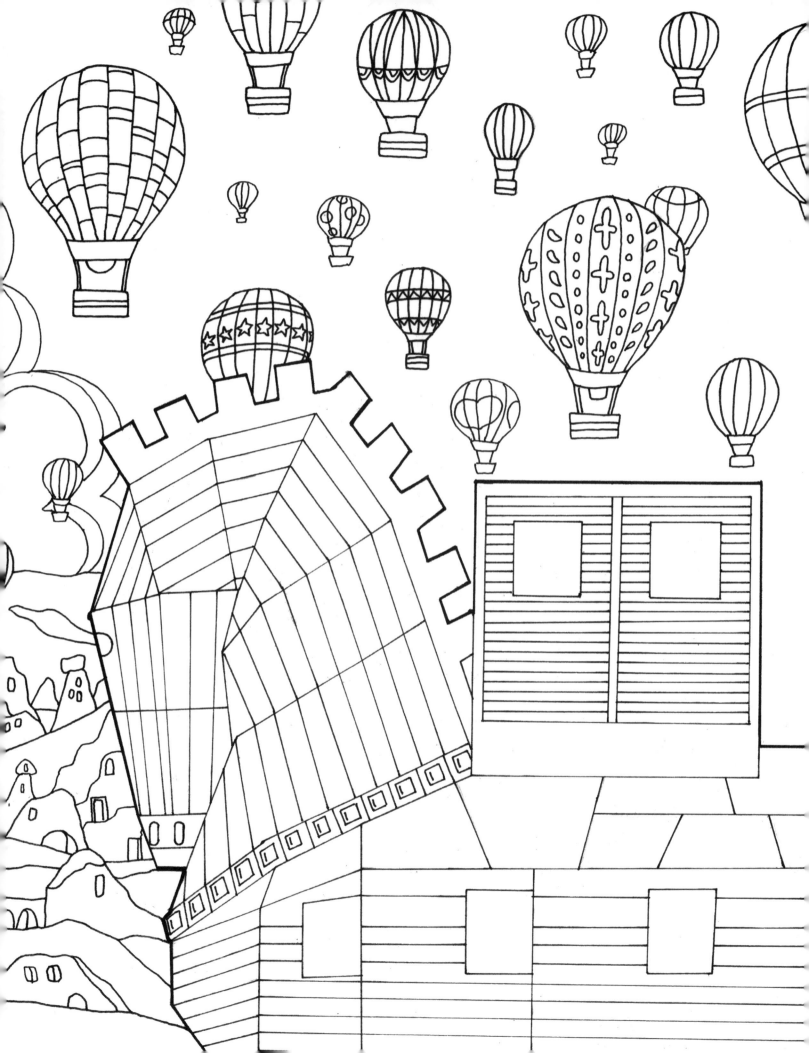

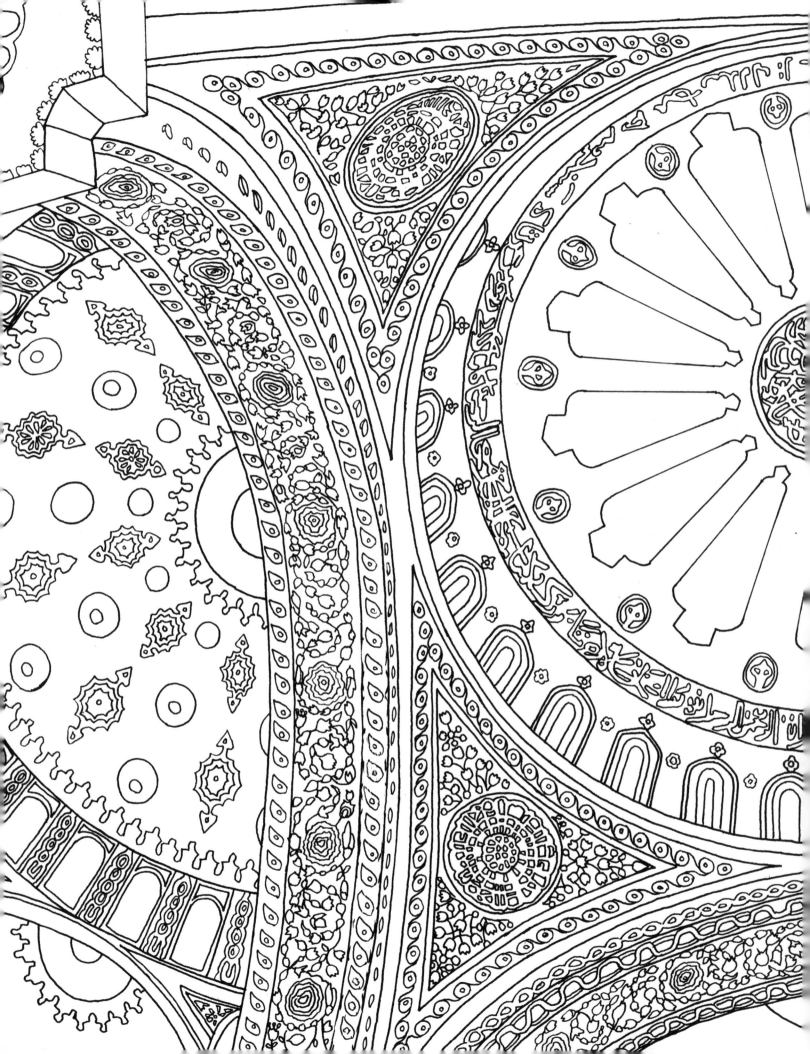

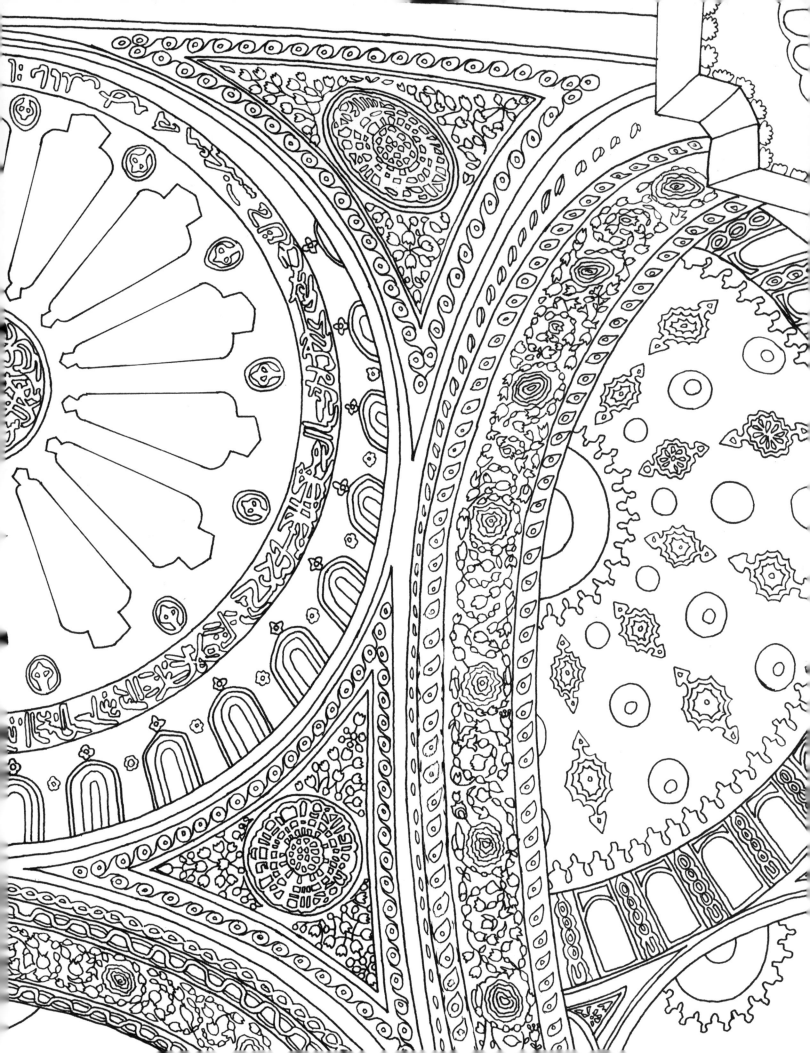

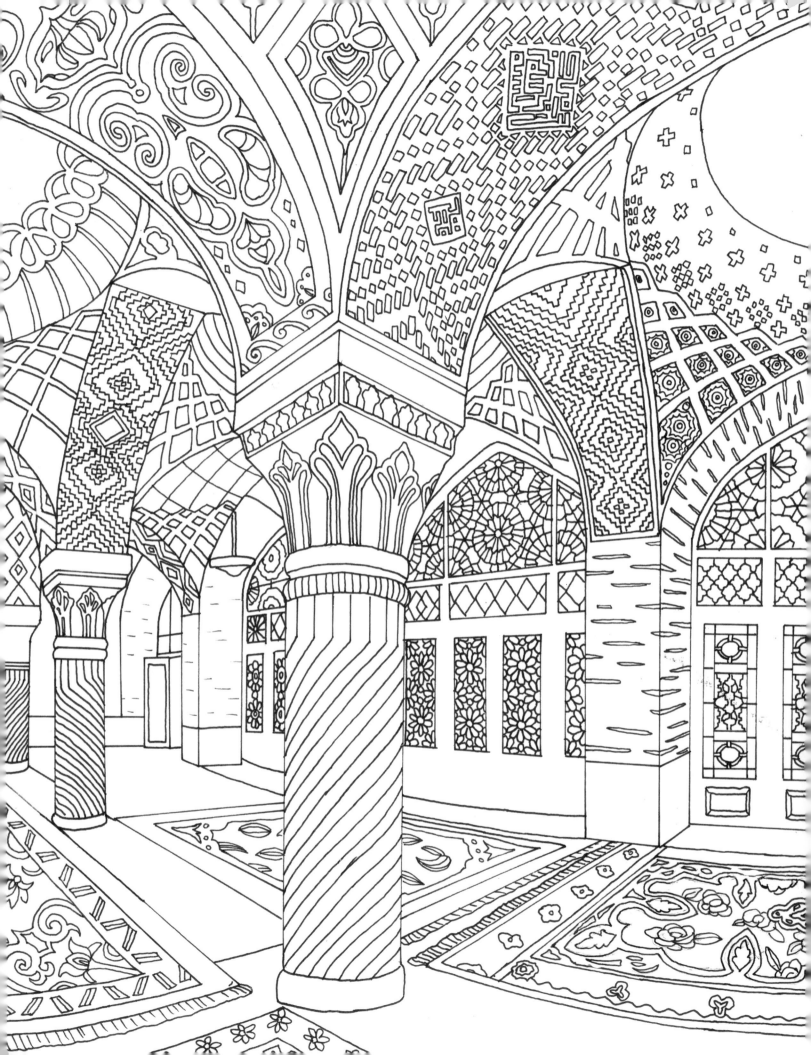

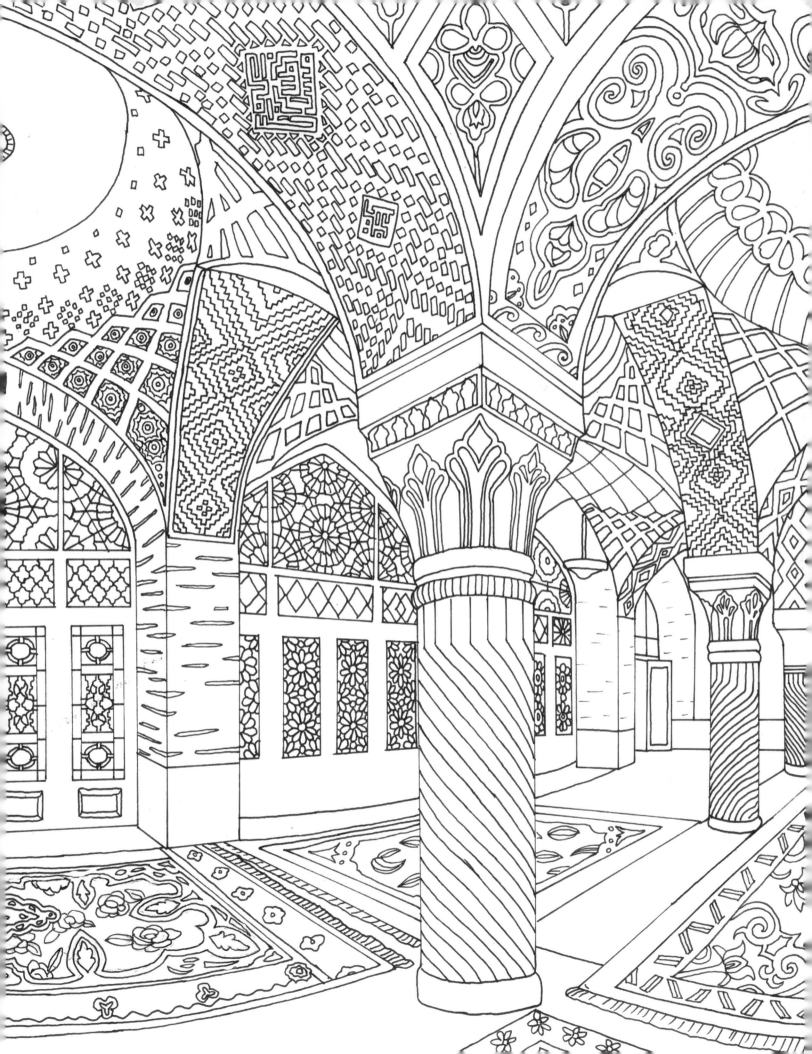

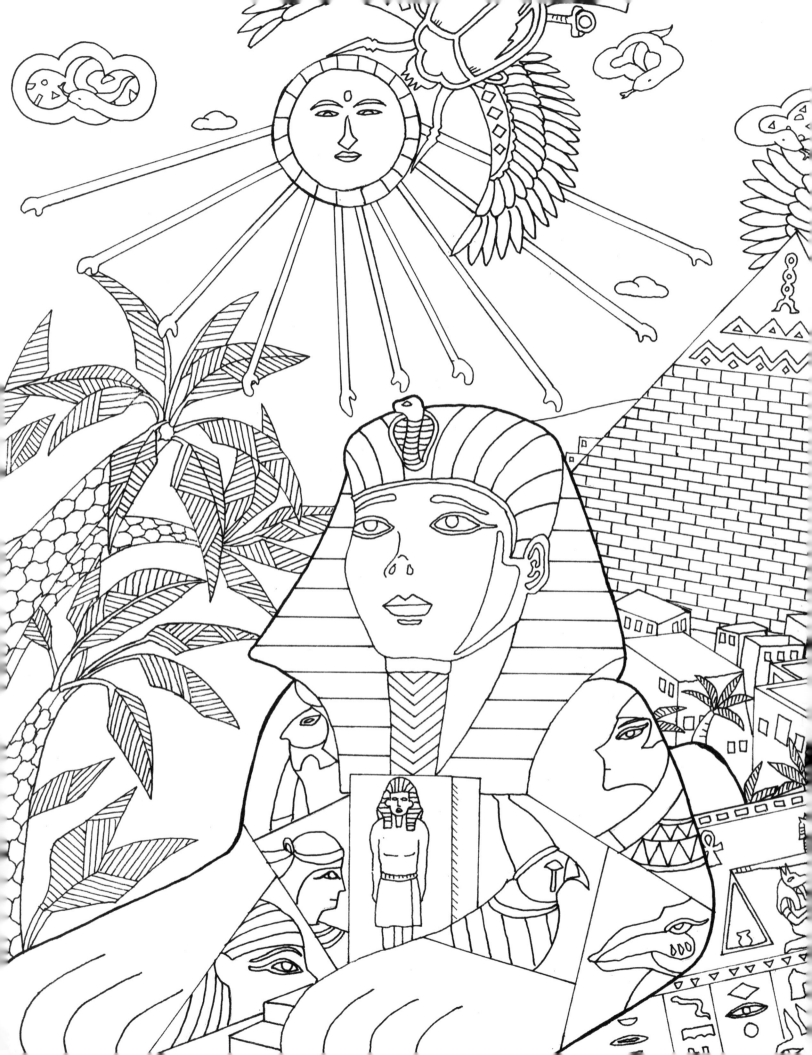

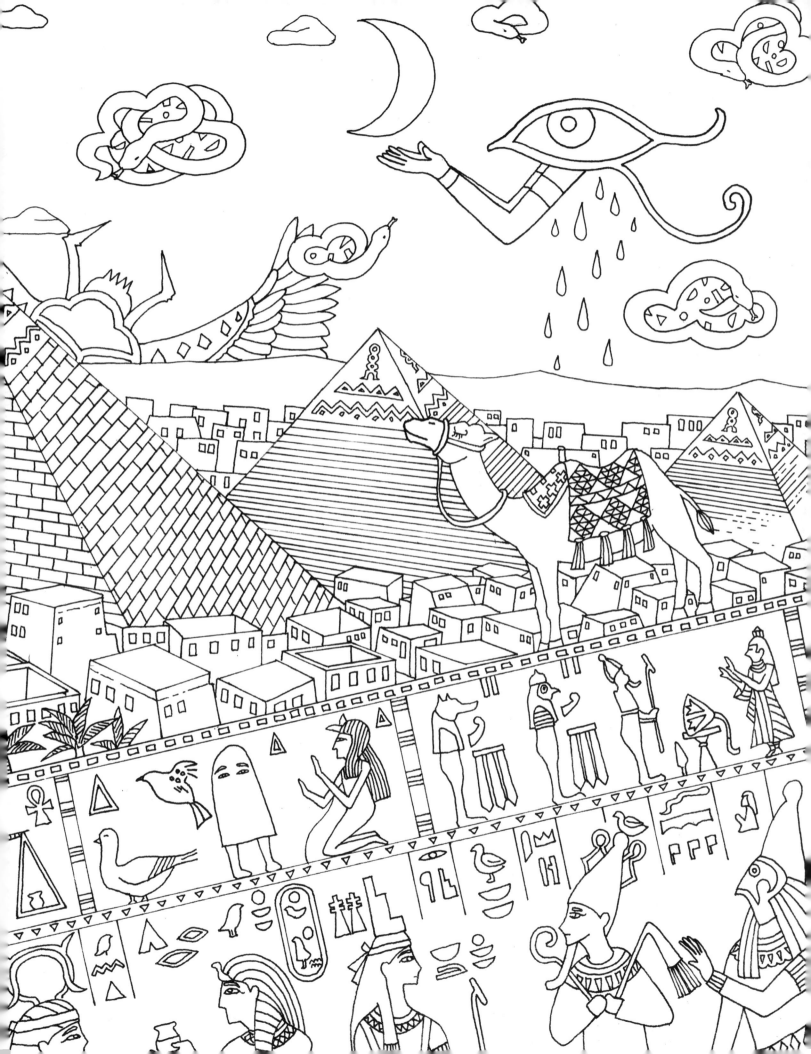

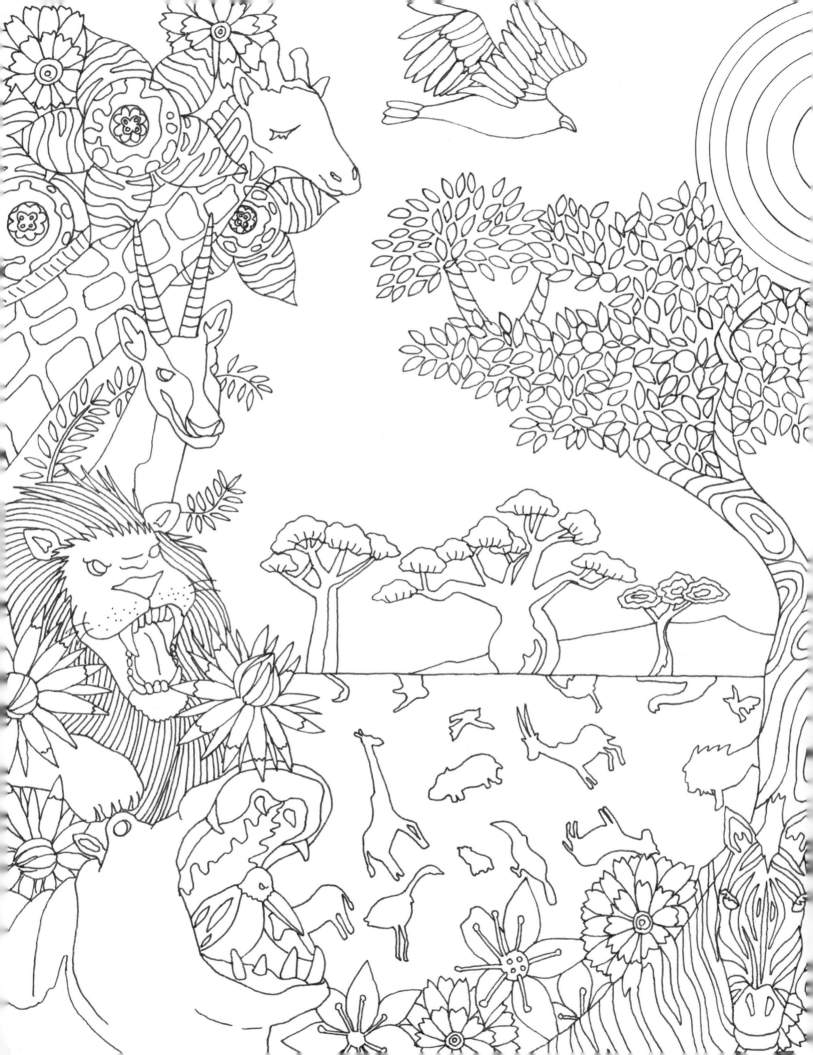

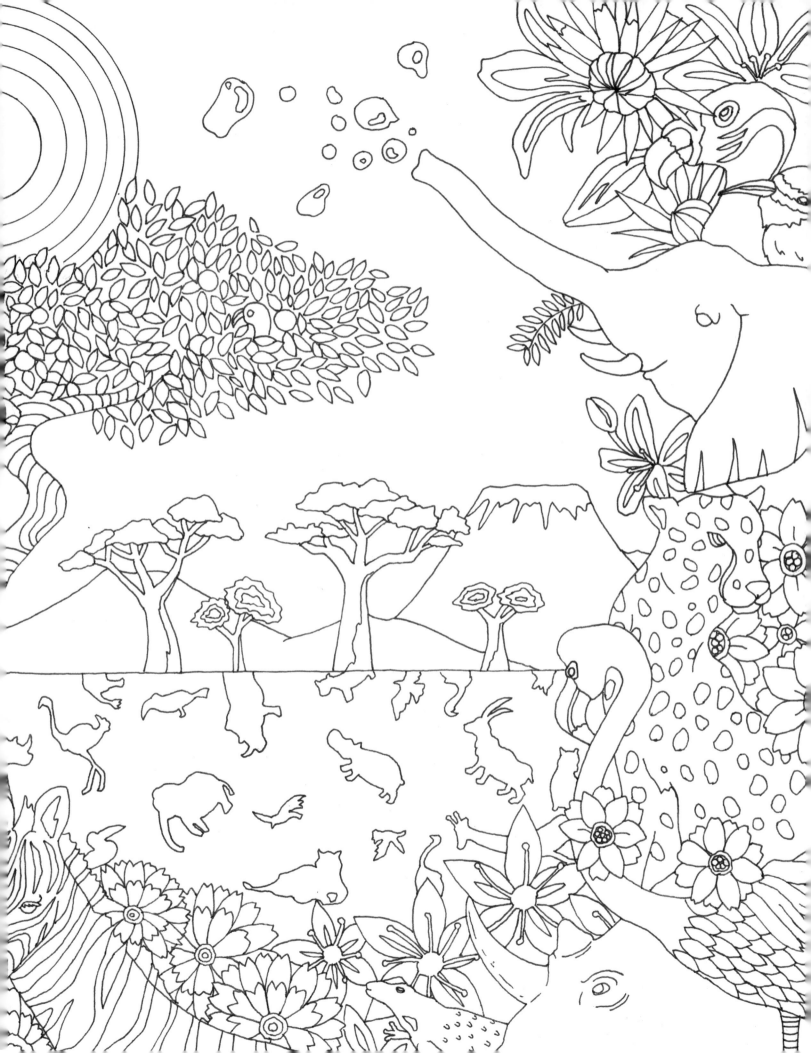

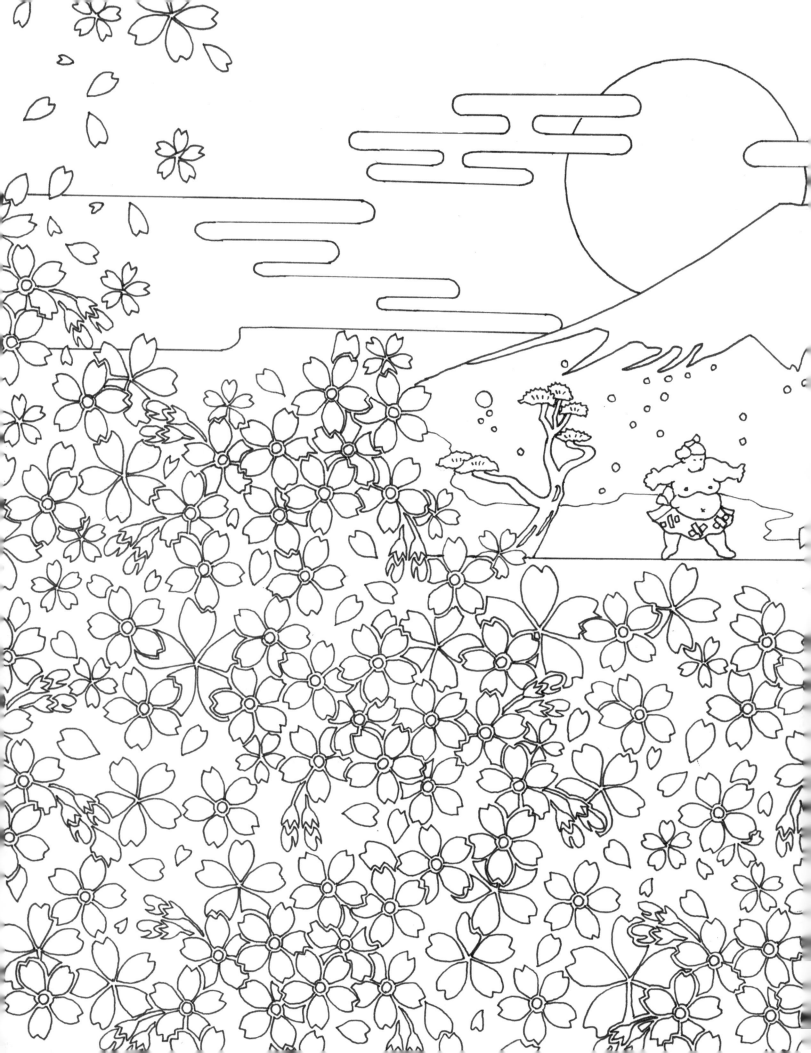

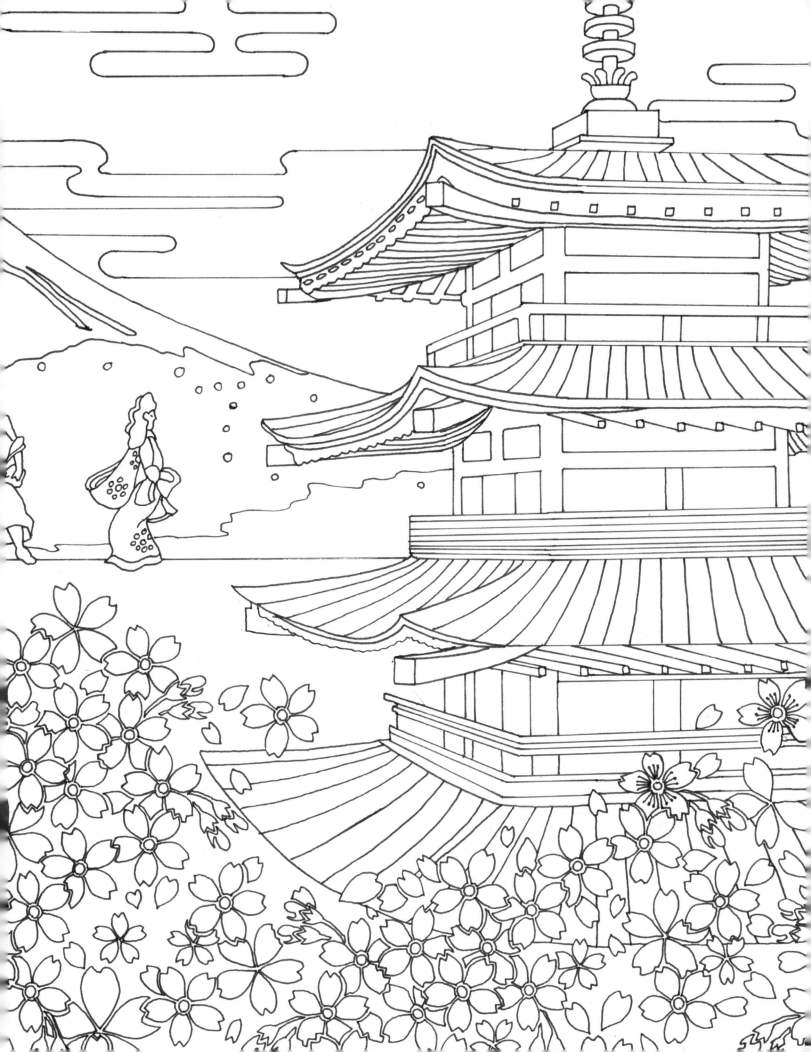

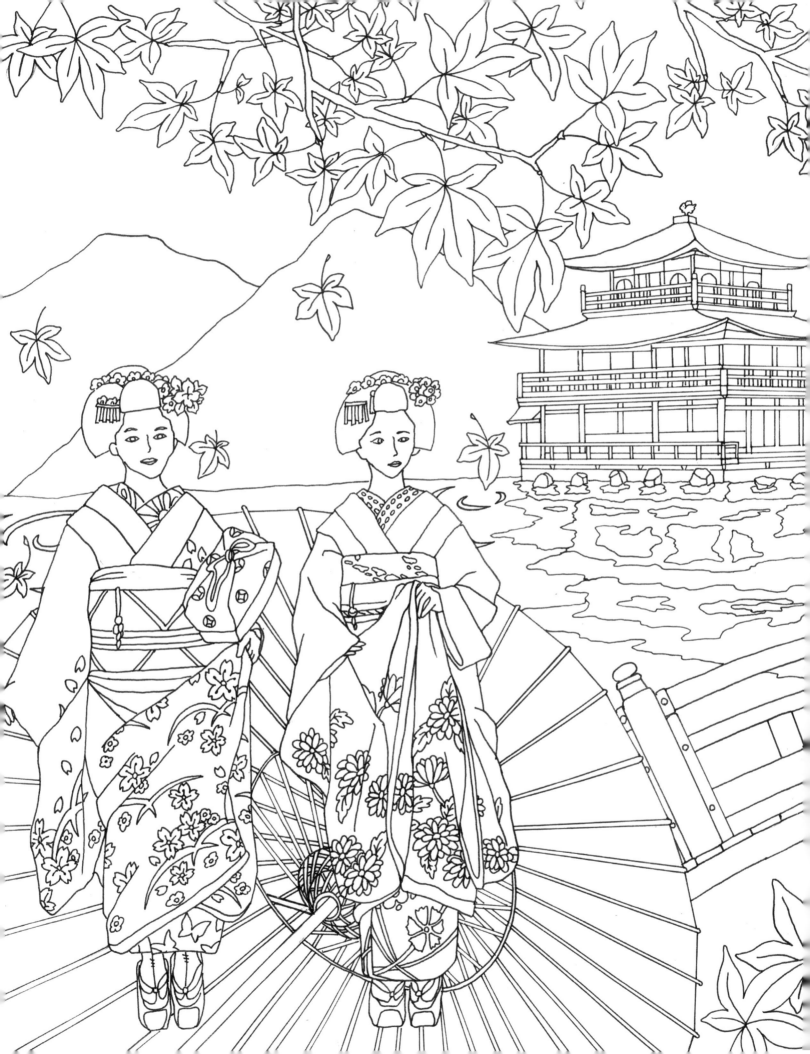

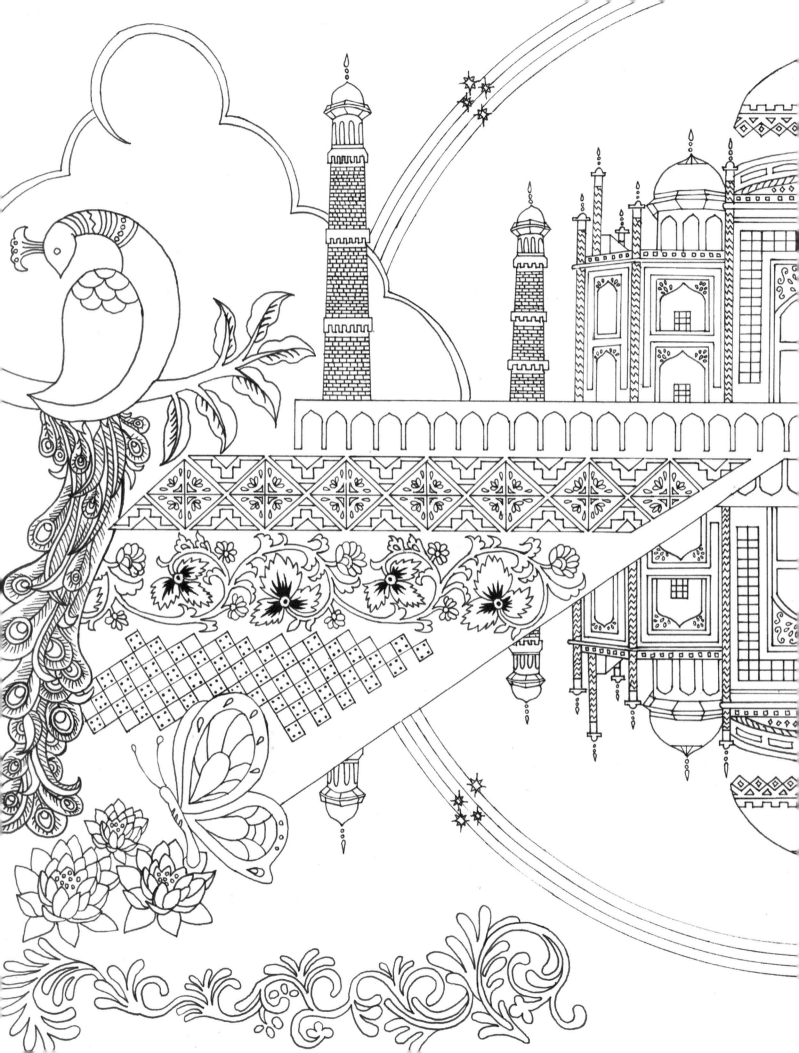

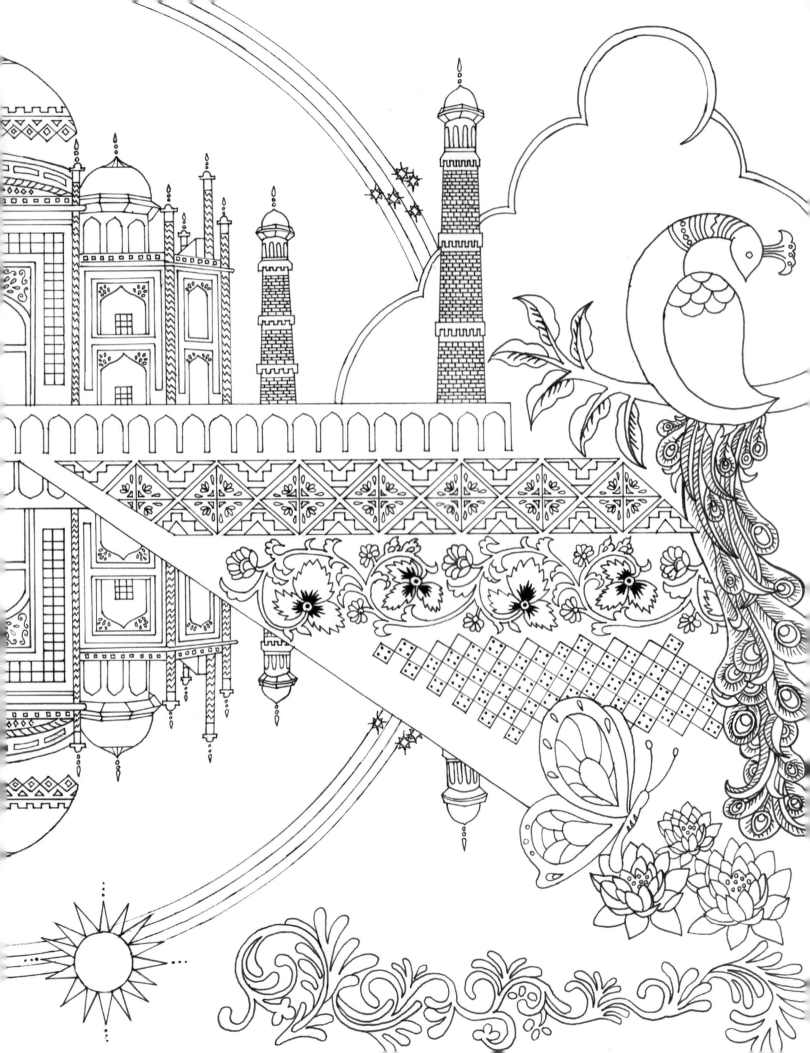

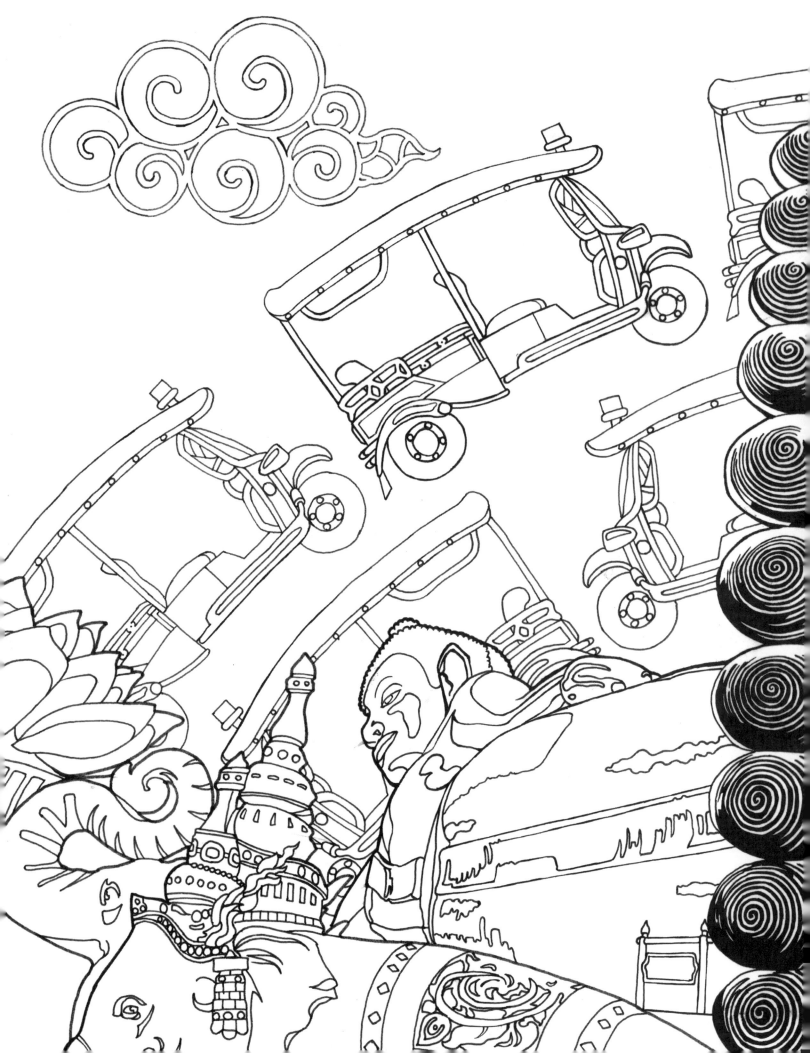

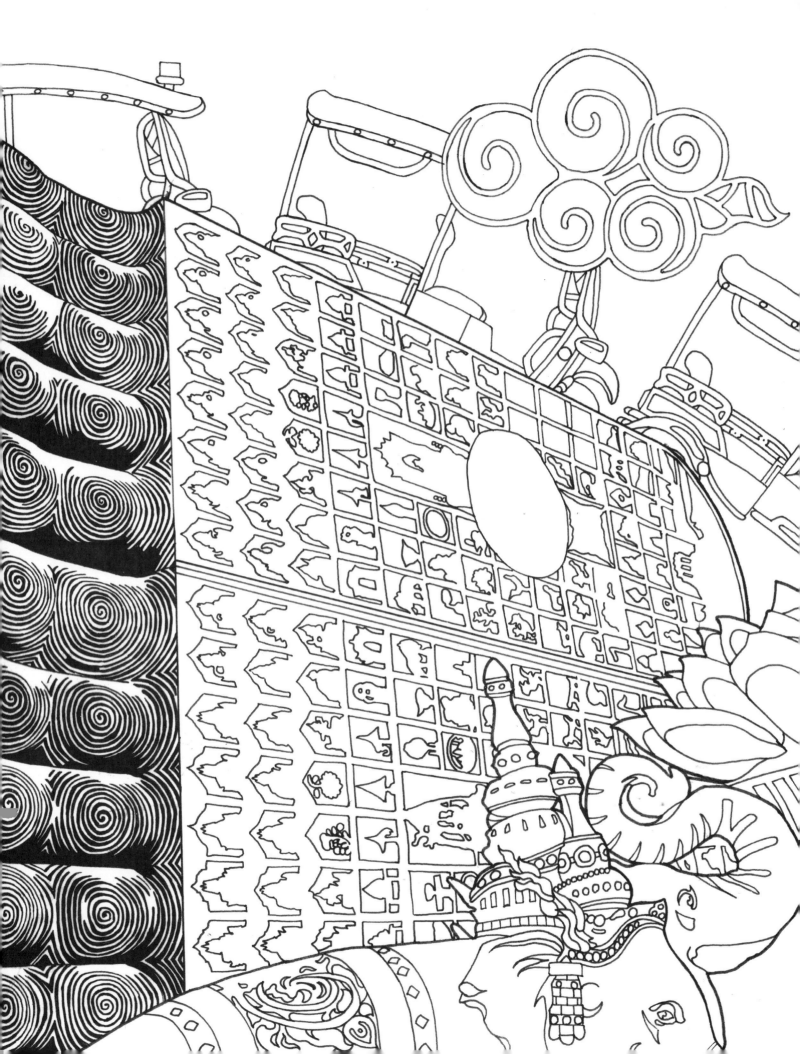

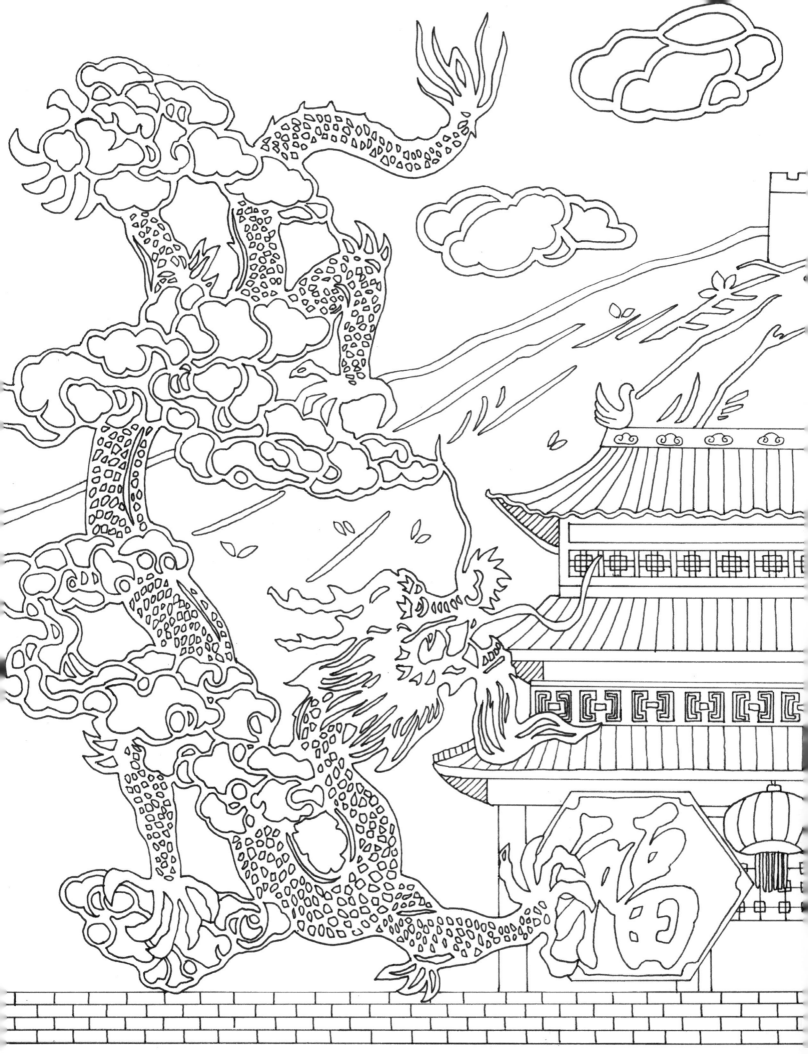

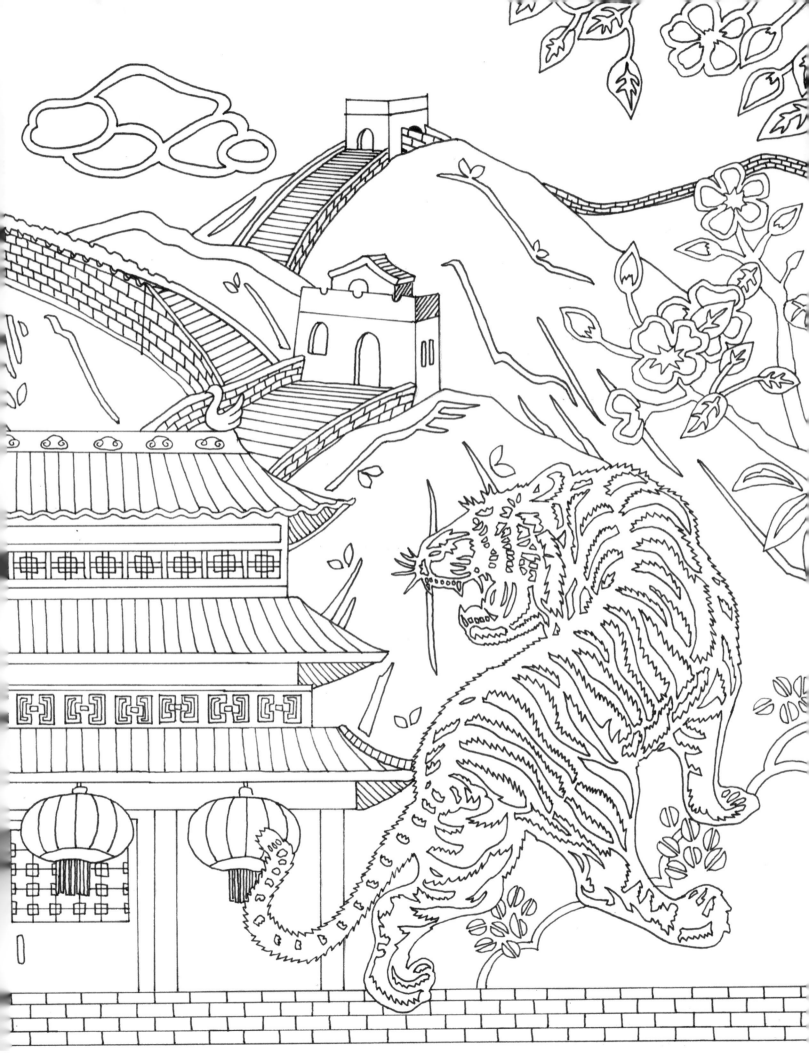

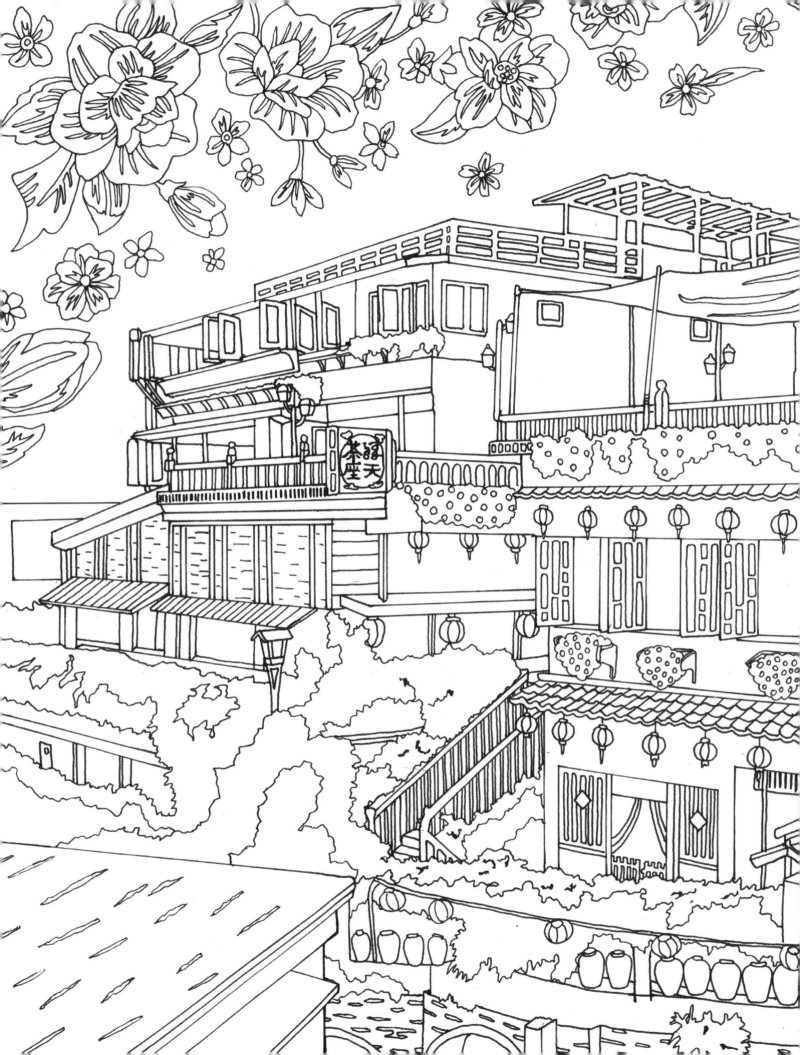

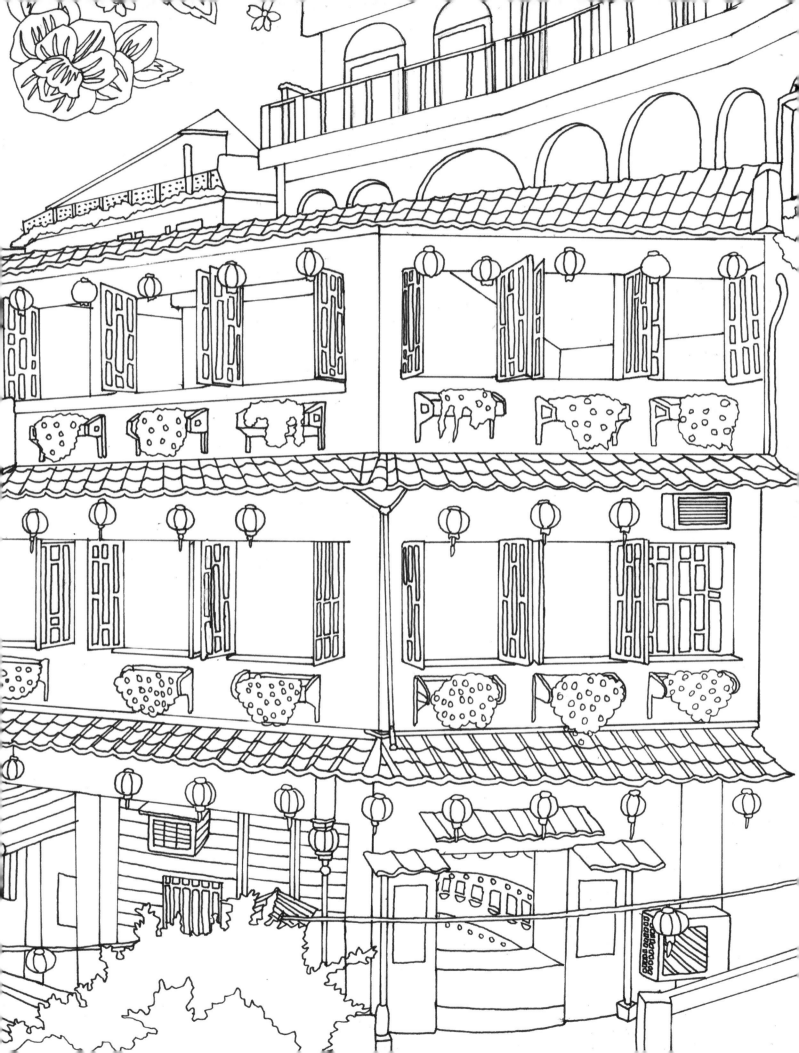

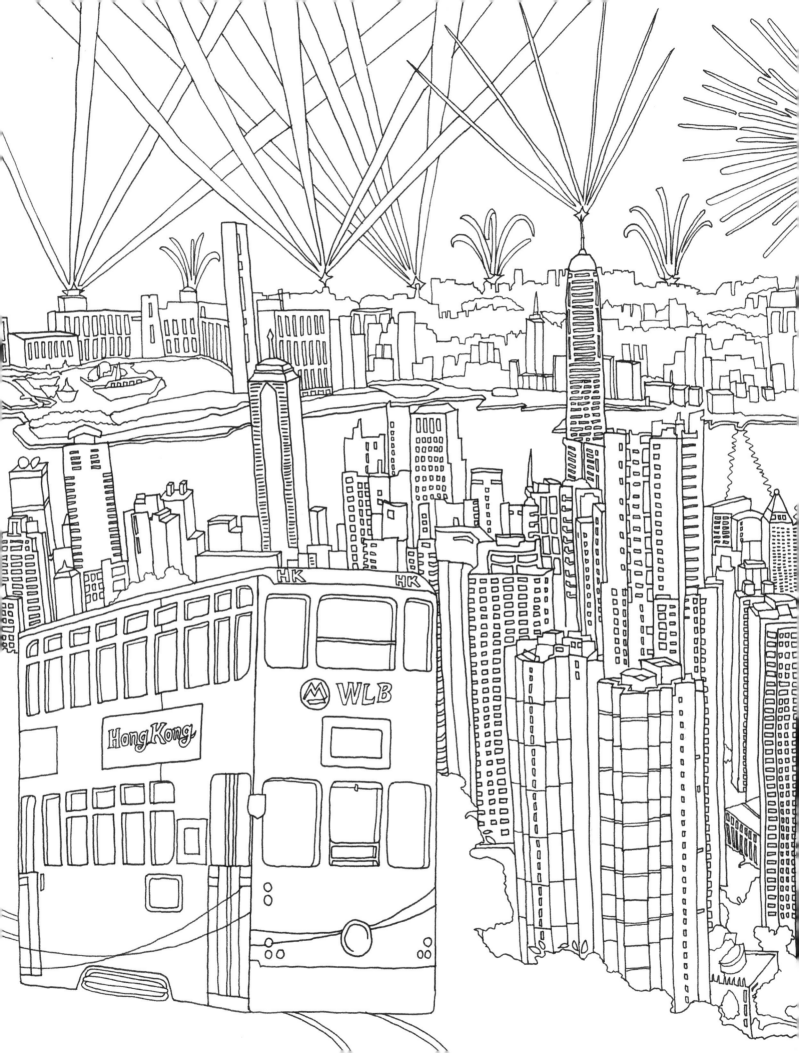

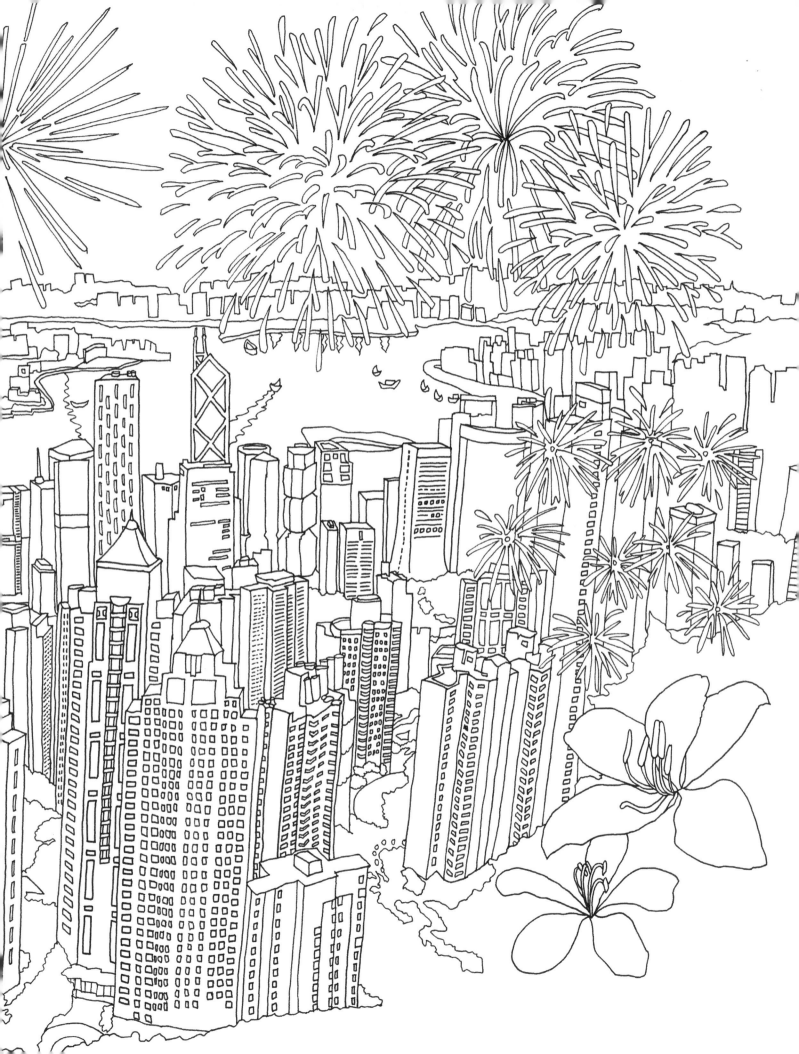

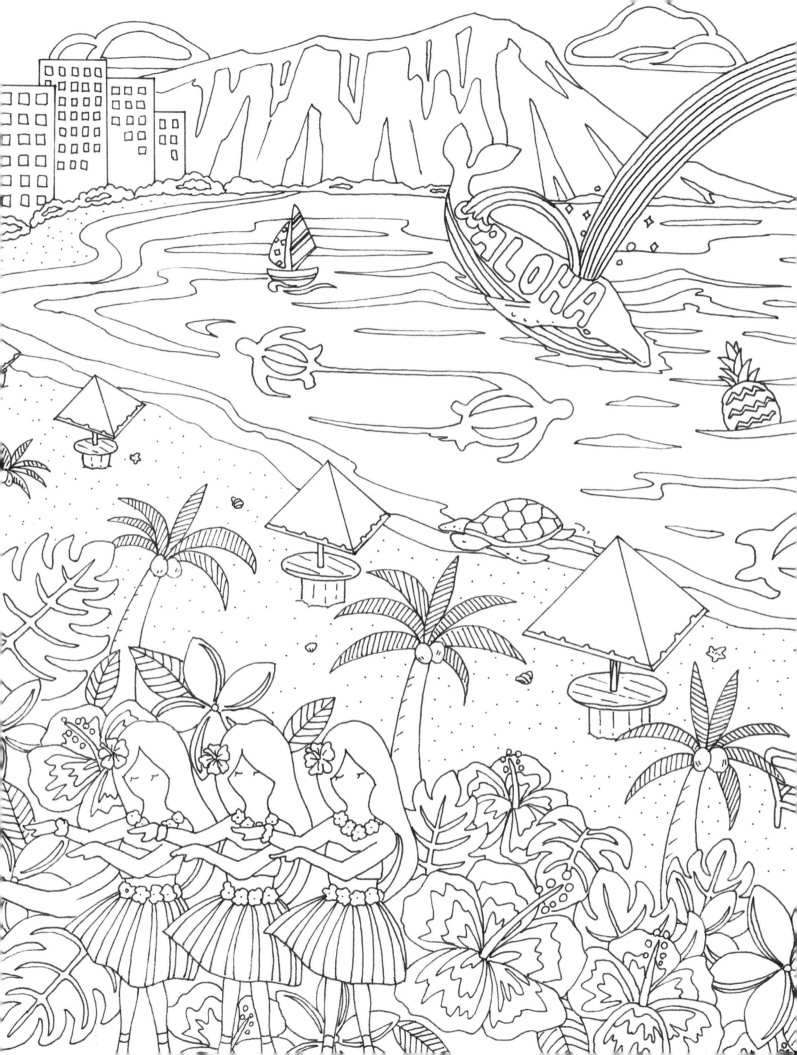

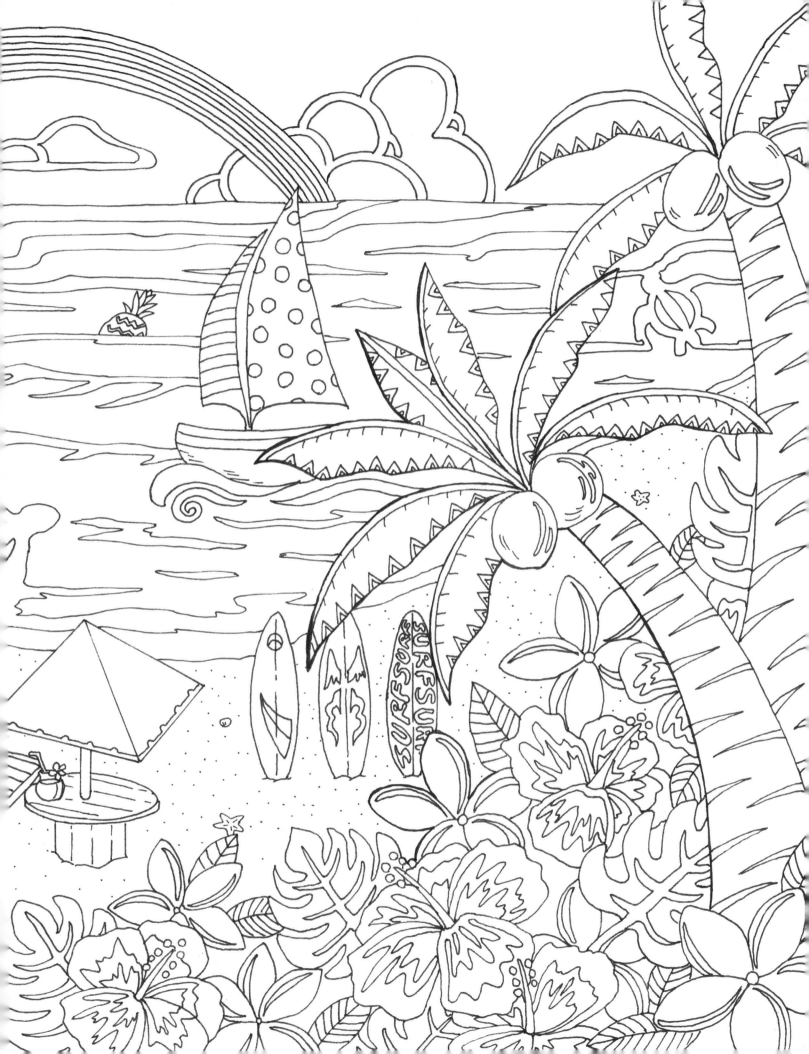

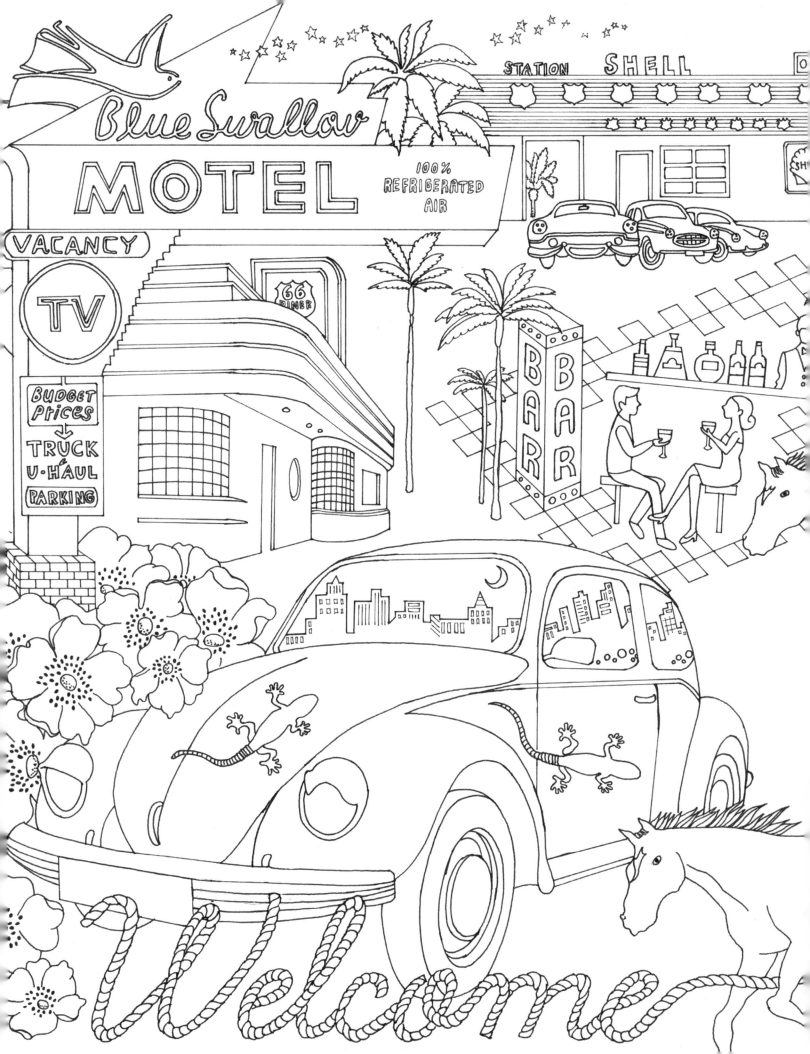

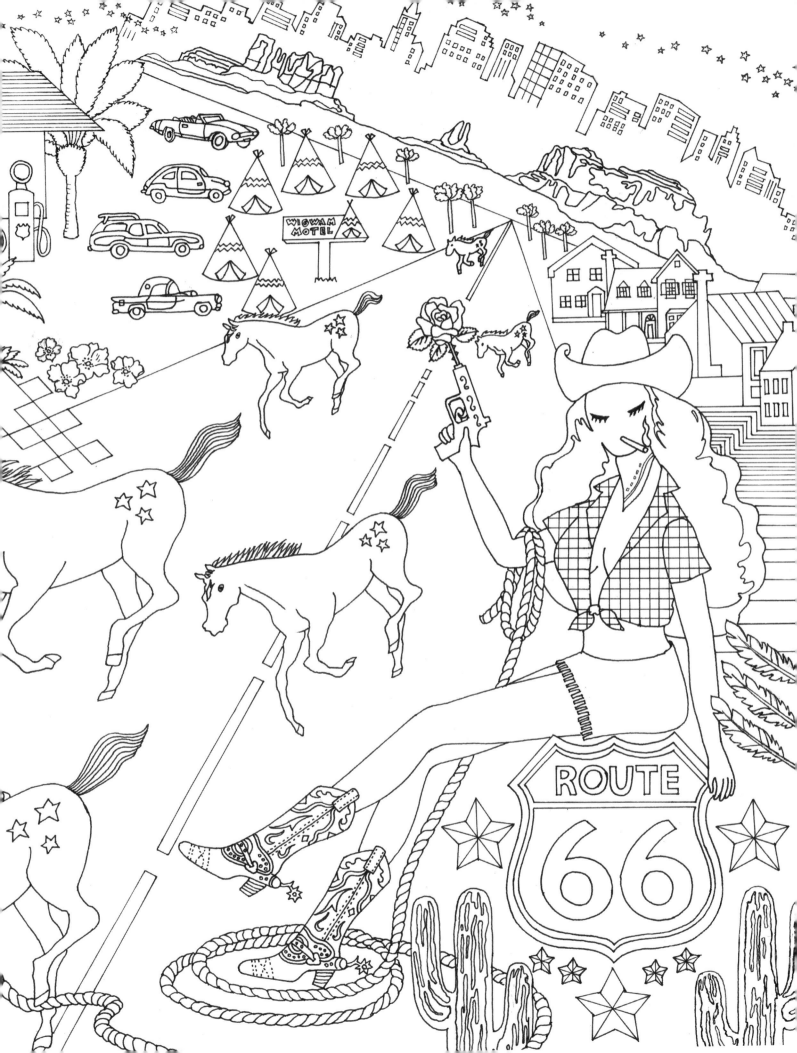

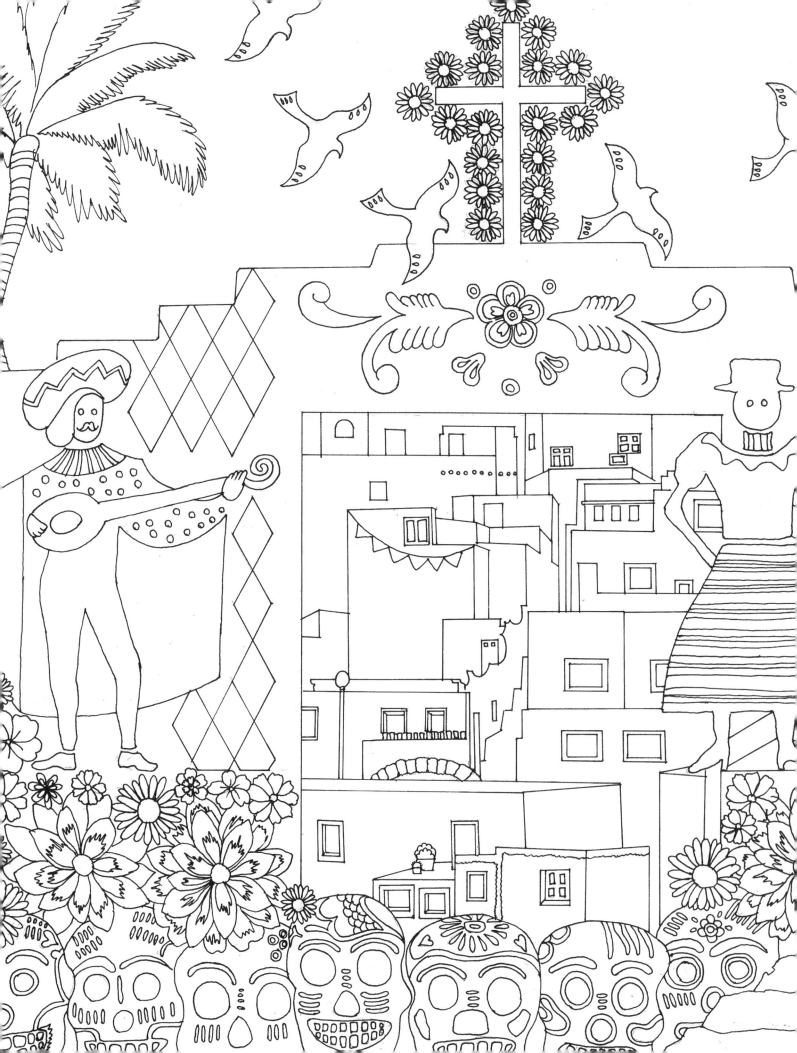

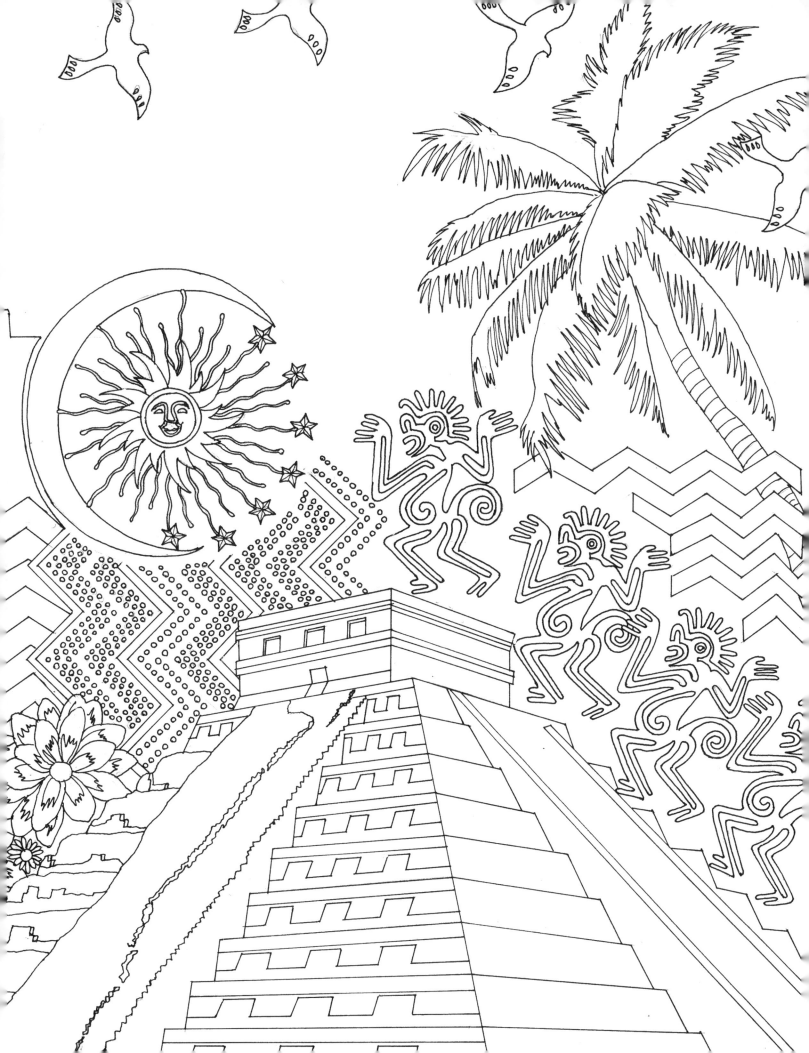

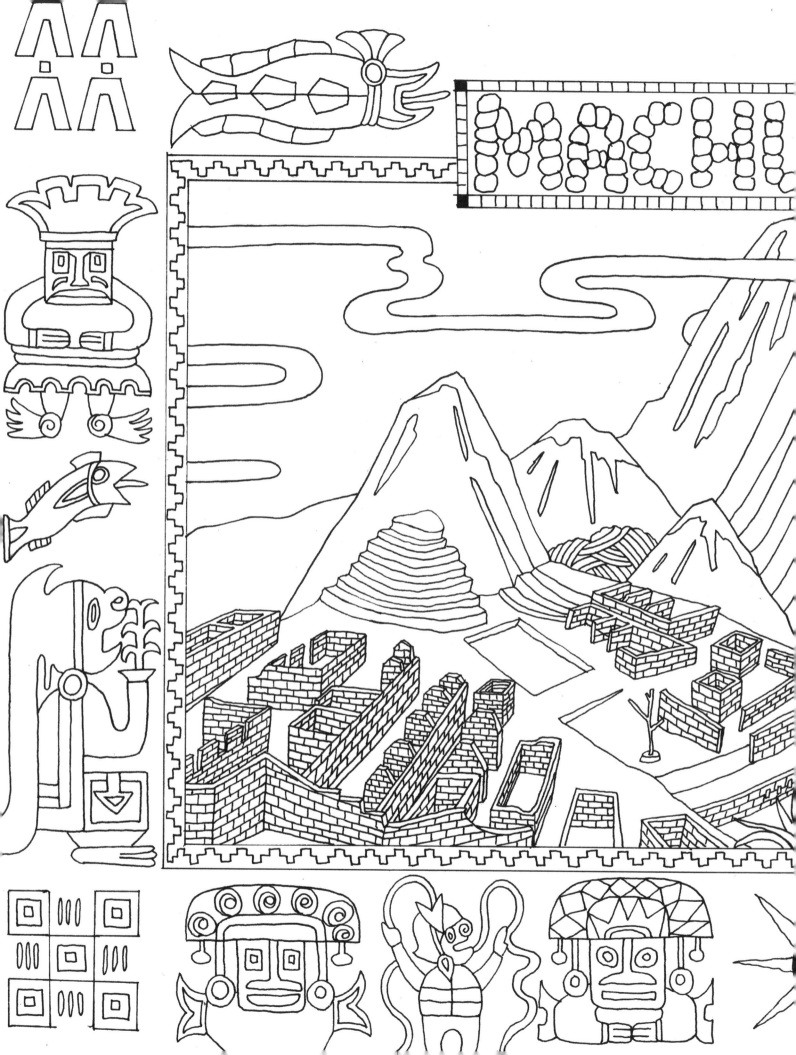

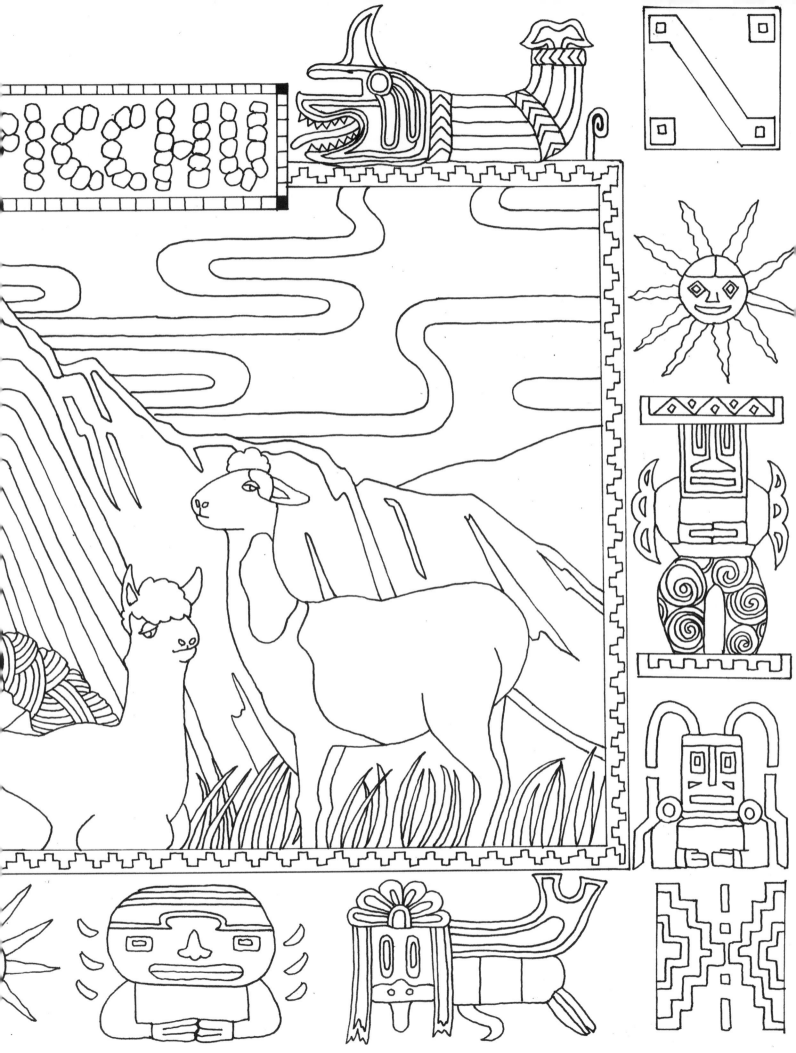

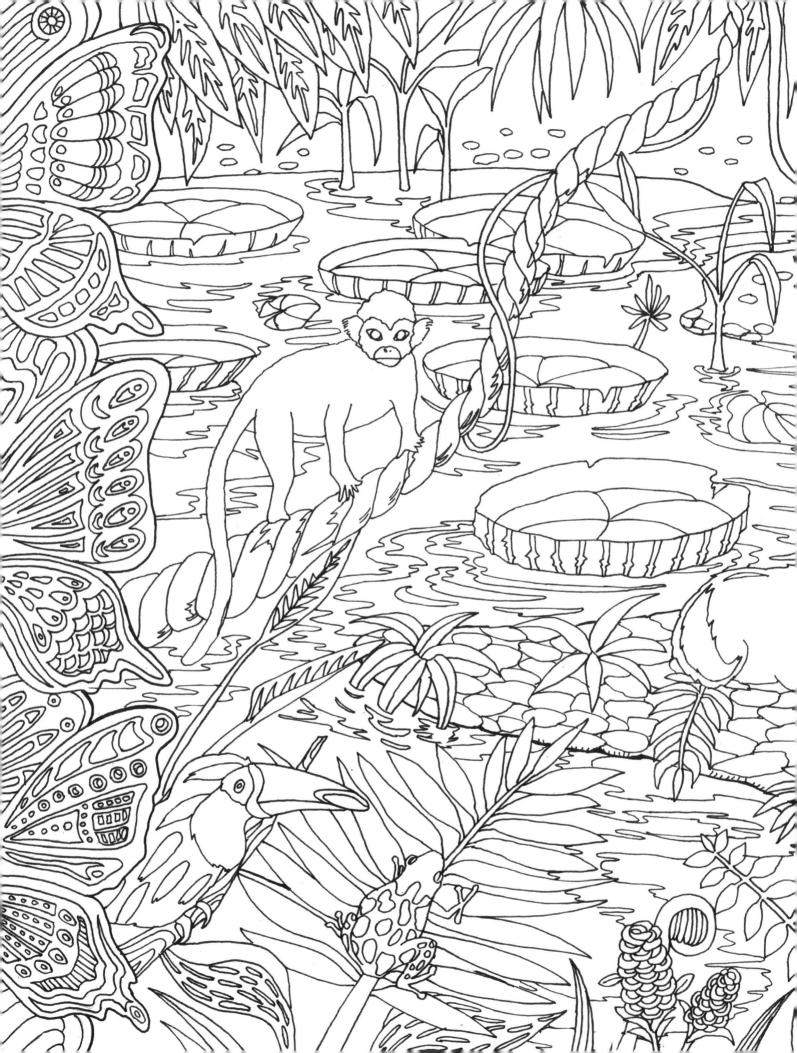

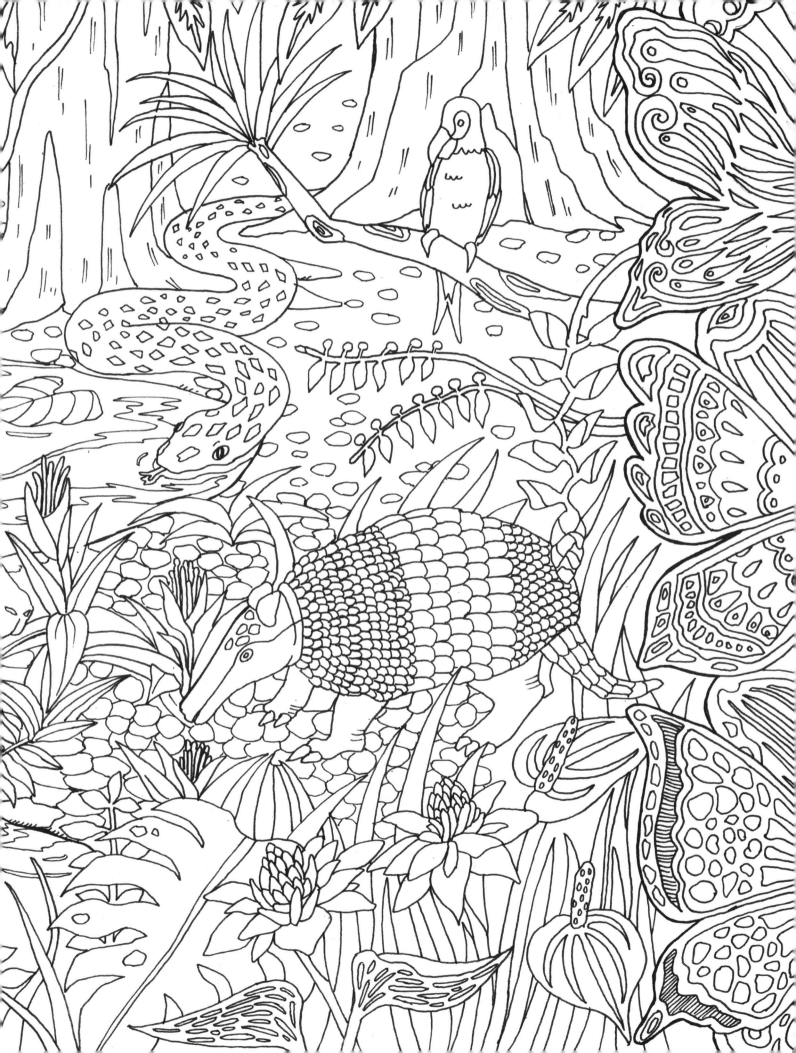

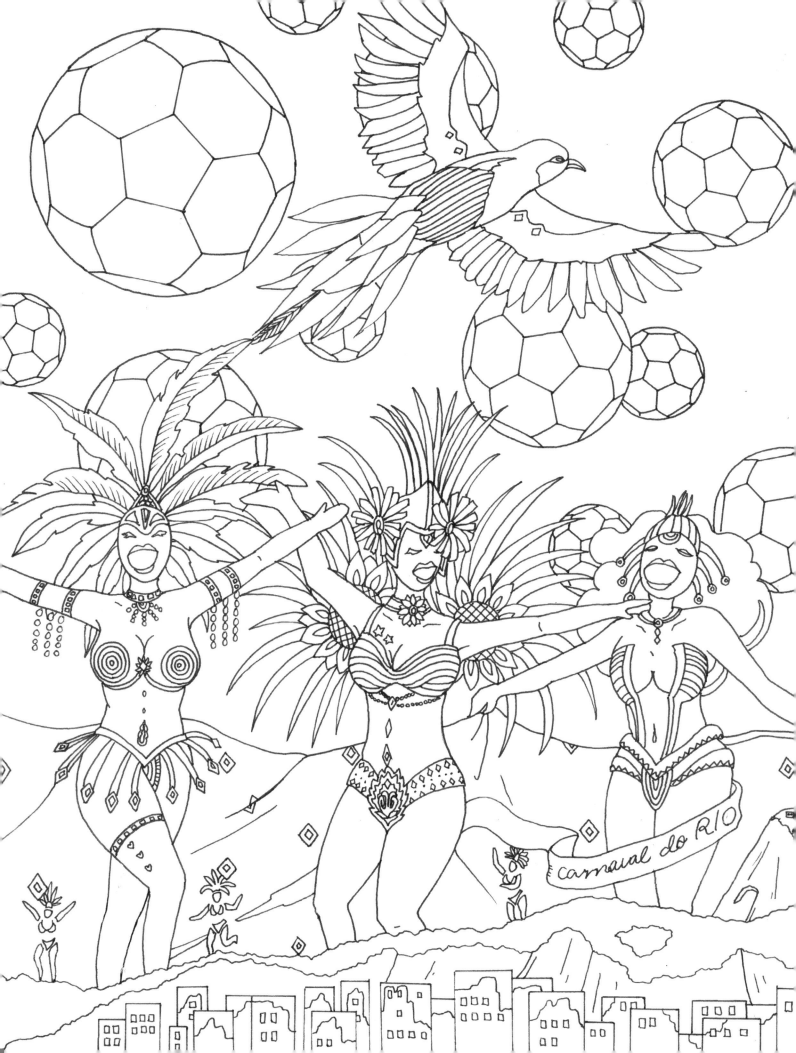

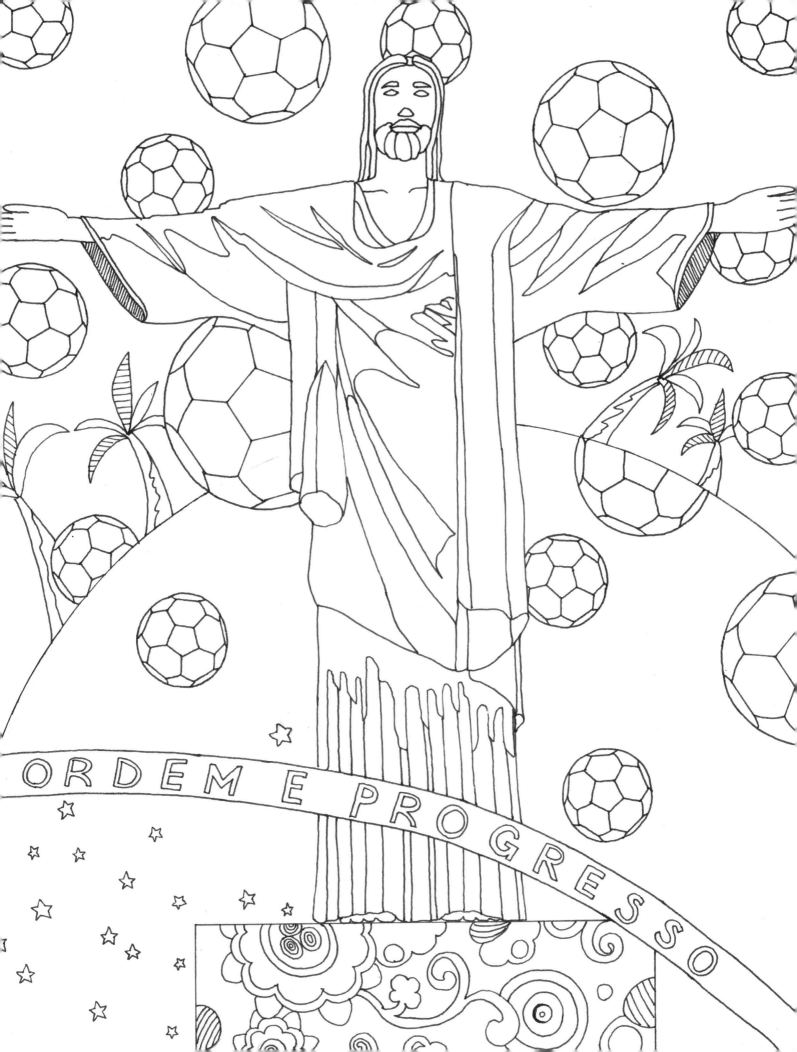

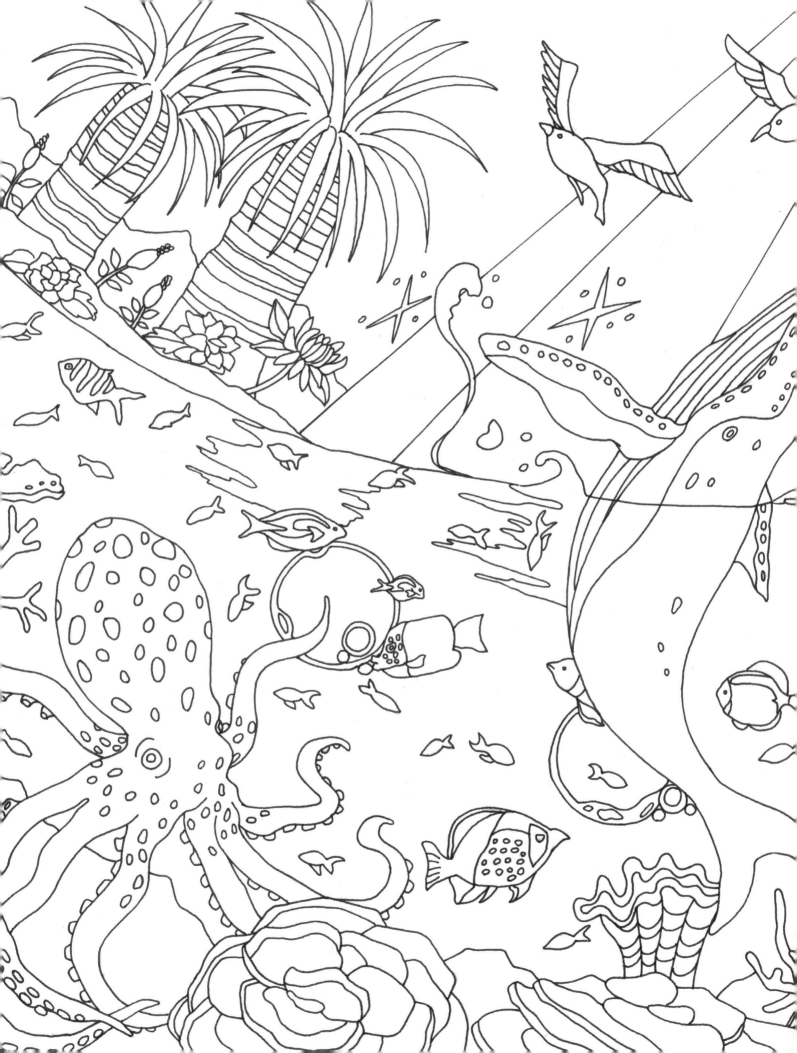

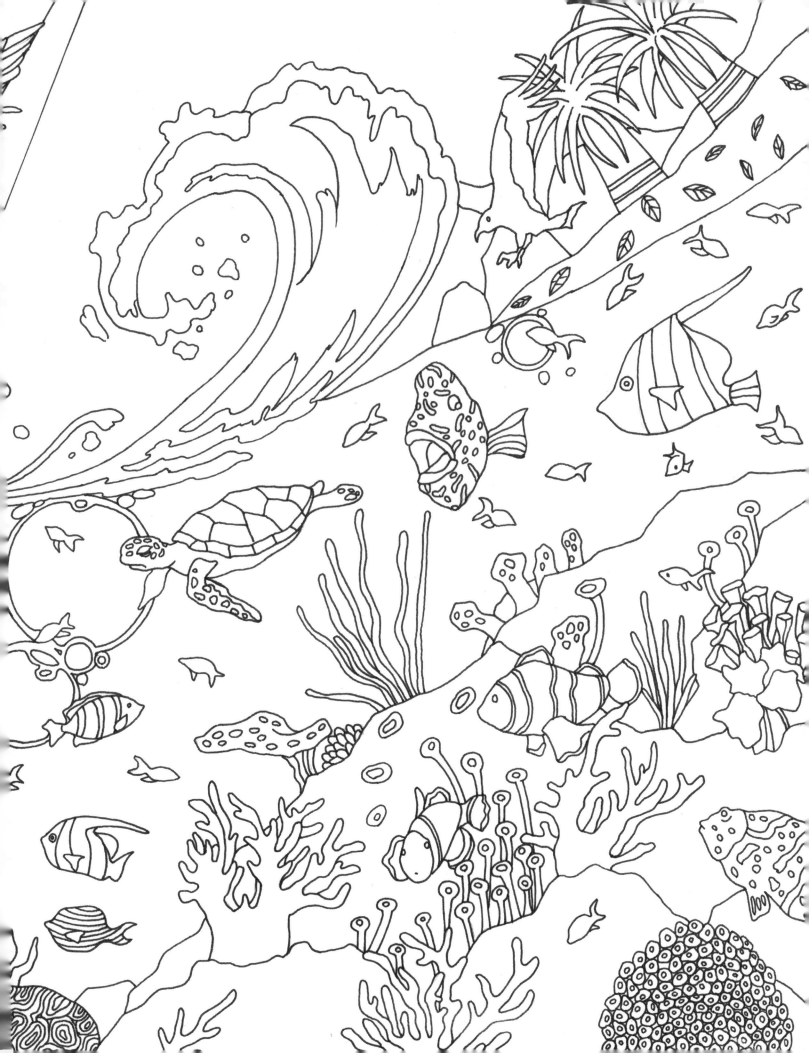

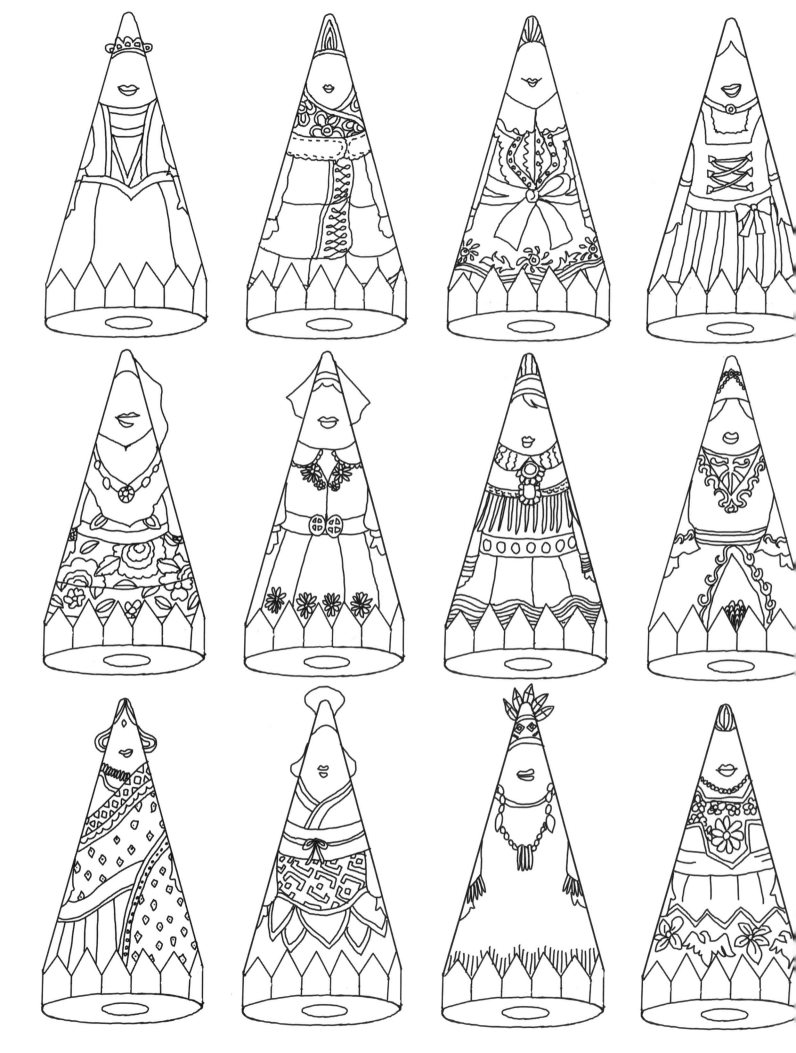

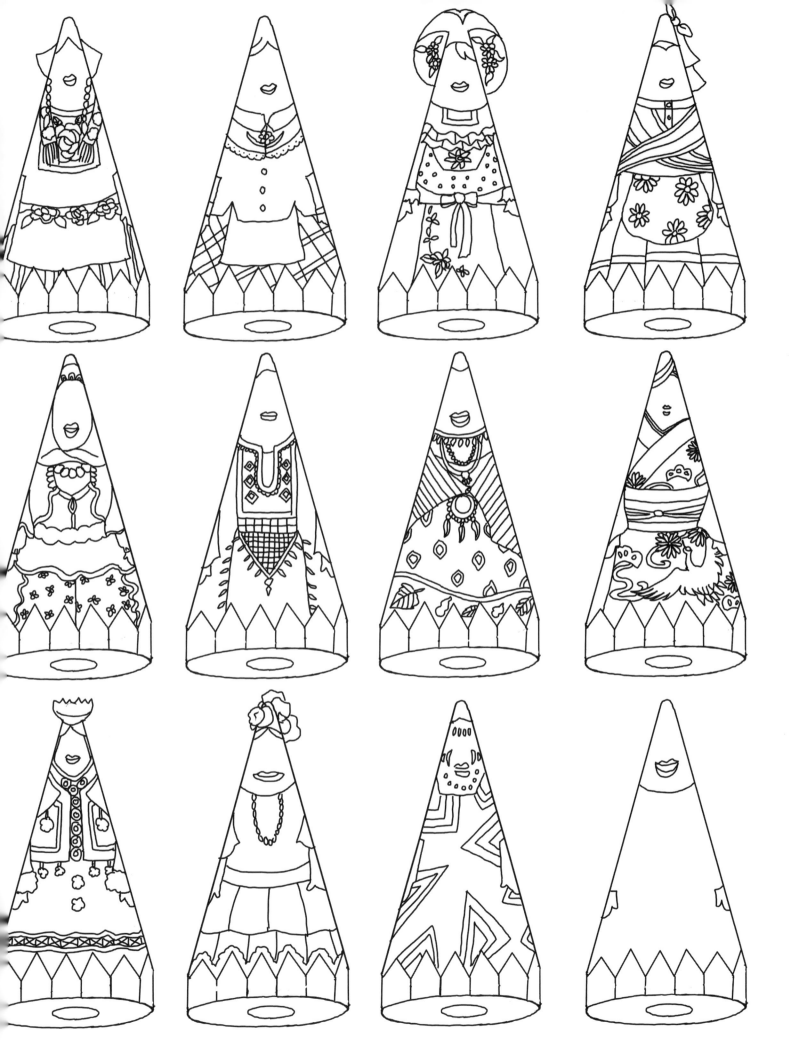

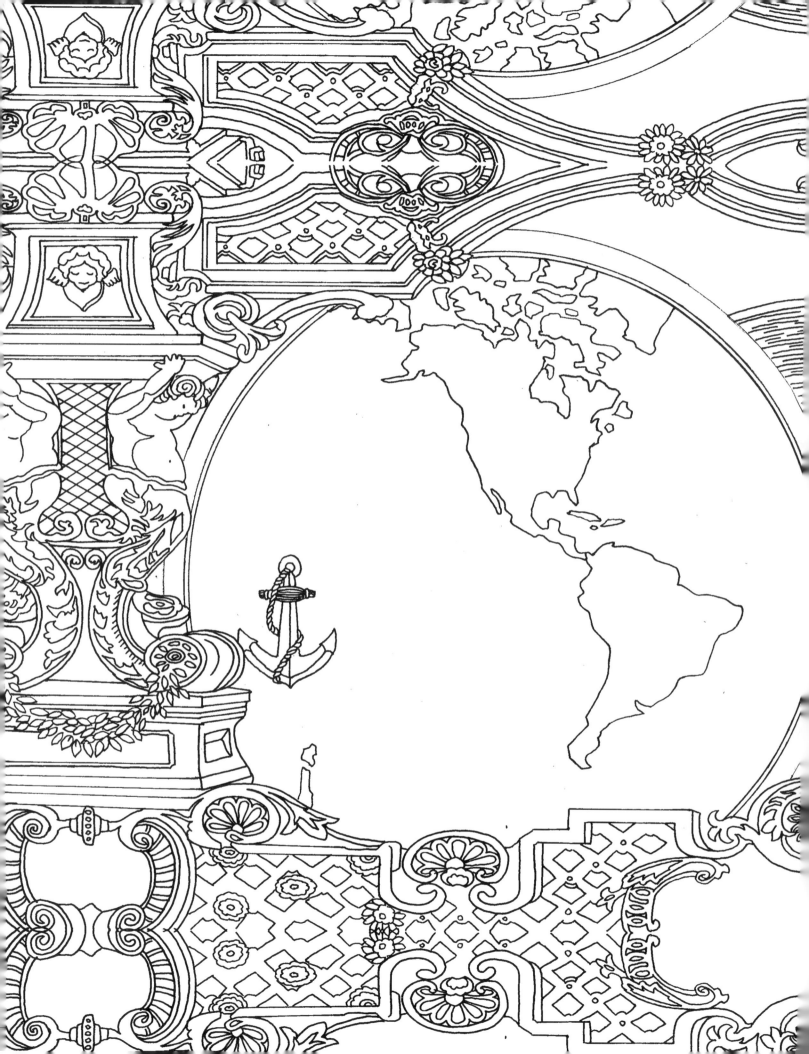

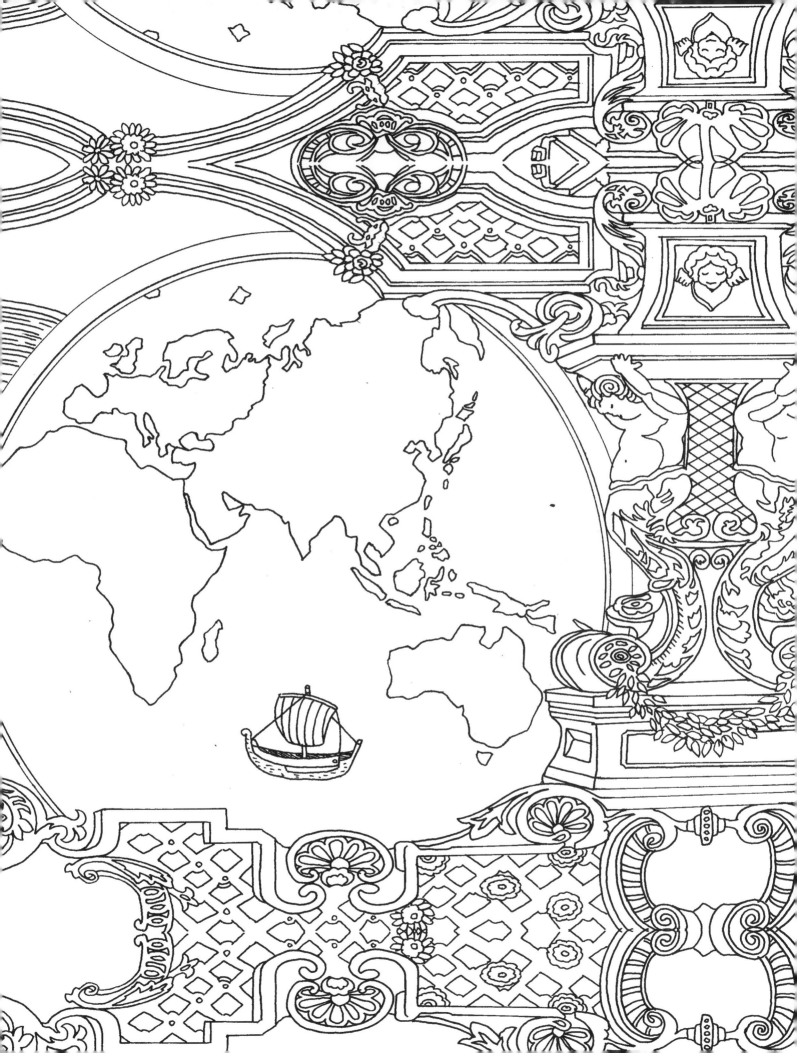

Around the World in 80 Colors: Coloring Across the Continents
ISBN: 13579108642

English edition first published in 2016 by Get Creative 6,
An imprint of Mixed Media Resources, LLC
161 Avenue of the Americas, New York, NY 10013

Originally published in the Japanese language by Boutique Sha, Inc.
English language rights, translation & production by World Book Media LLC
www.worldbookmedia.com

SEKAI NO ZAKKEI TO MACHINAMI NO NURIE BUKKU
©2015 Boutique Sha

Library of Congress Cataloging-in-Publication Data not available at time of
printing.

Printed in China

10 9 8 7 6 5 4 3 2 1

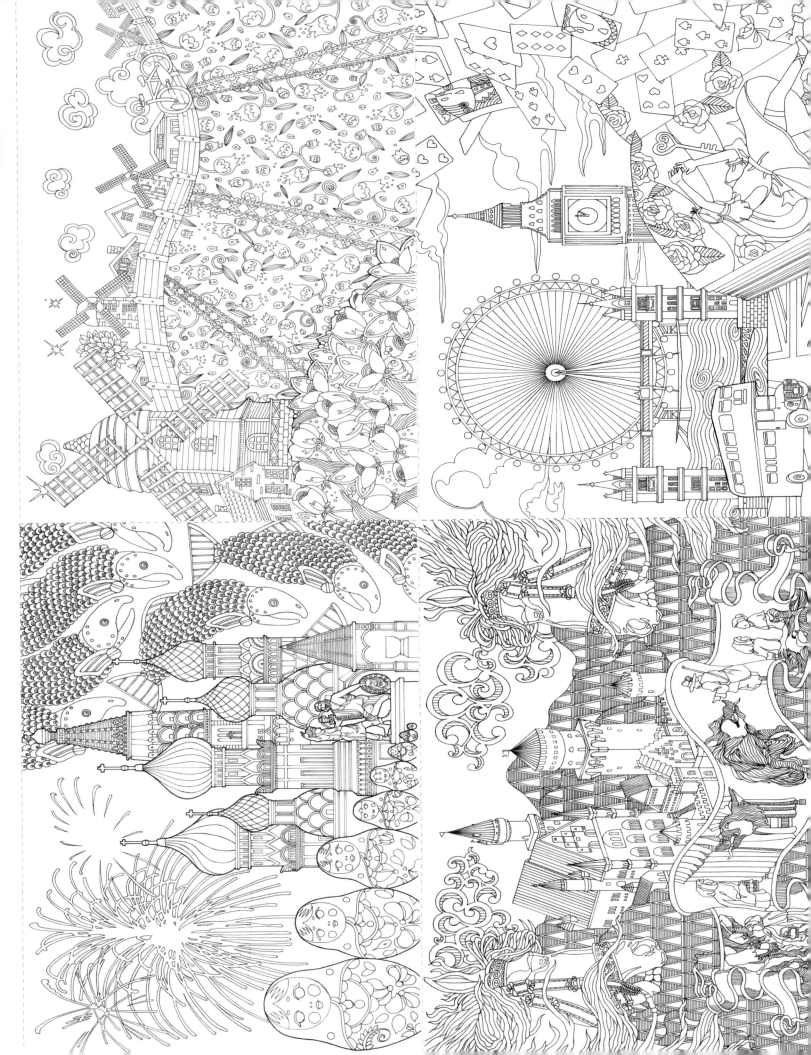

London: Past and Present (England)

Tulips and Windmills (Holland)

Neuschwanstein Castle (Germany)

Saint Basil's Cathedral in Moscow (Russia)

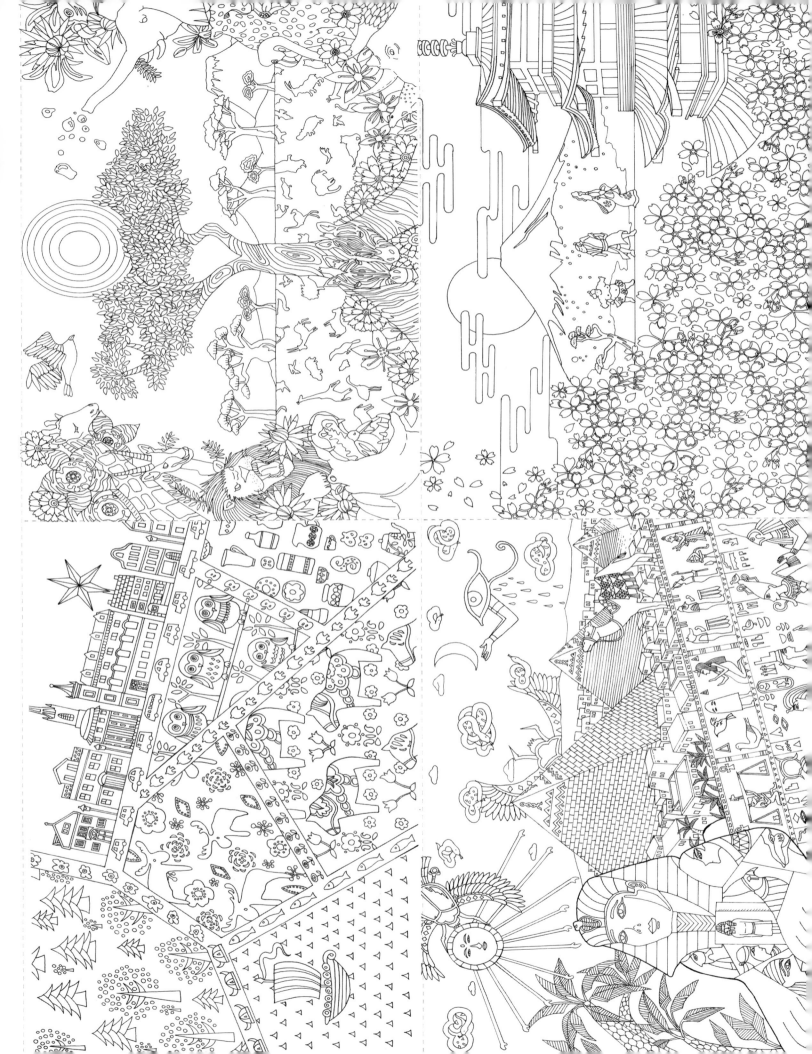

Mount Fuji's Cherry Blossoms (Japan)

The African Savanna

The Great Pyramids of Giza (Egypt)

Splendid Stockholm (Sweden)

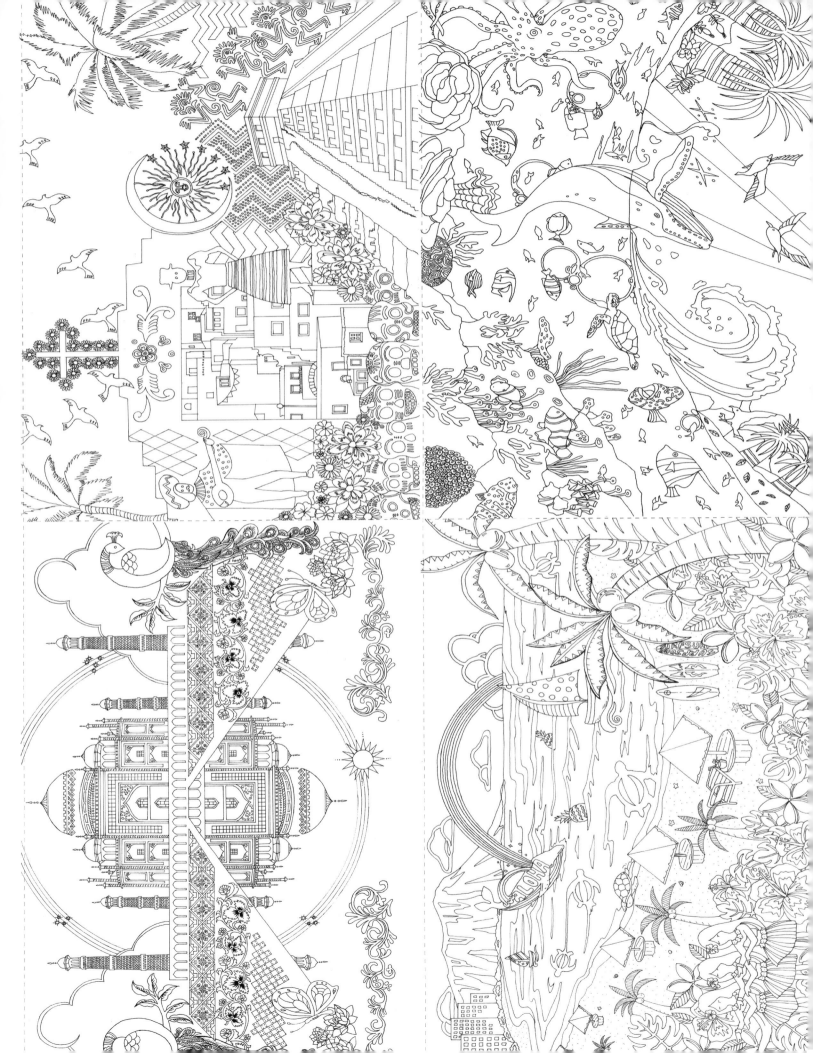

The Great Barrier Reef (Australia)

The Day of the Dead Festival (Mexico)

Aloha: Welcome to Hawaii's Waikiki Beach (USA)

Taj Mahal (India)